COLOMBIA BY COLORS

COLOMBIA

BY COLORS

PHOTOGRAPHY

This book has been created,
edited and published in Colombia by
VILLEGAS ASOCIADOS S.A.
Avenida 82 n.º 11-50, Interior 3
Telephone (57-1) 616 17 88, fax (57-1) 616 00 20
Bogotá D. C., Colombia
e-mail: informacion@villegaseditores.com

© Villegas Editores 2008

Direction, design and edition
Benjamín Villegas

Art Department
Adriana Botero / Giovanna Monsalve

Captions
Juan David Giraldo / Carolina Jaramillo Seligmann

English translation
Jimmy Weiskopf

All rights reserved by the editor
First edition, November 2008
First reprint, April 2009
Second reprint, November 2010
Third reprint, June 2012
ISBN 978-958-8306-27-8

VillegasEditores.com

COLOMBIA
8

WHITE
24

PINK
120

YELLOW
48

ORANGE
72

RED
96

BLACK
276

PURPLE
144

BROWN
252

BLUE
168

OCHRE
228

GREEN
192

Colombia has been a constant during my
life as an editor. You have only to look at the
catalogue of our publishing house to see the dimen-
sions of that truth. *Colombia from the air, Colombia a new
vision, Panoramic Colombia, Colombia 360º cities and towns, Un-
seen Colombia* — these are some of the first books that leap to my mind,
whose very titles show how important Colombia has been to us.
They aren't the only ones, however. This fascination with the country has led
us down other paths, as seen in such books as *The taste of Colombia, The life
in Colombia, Gardens of Colombia, Country Houses in Colombia,* among others,
which focus on specific aspects of Colombian culture. Now I am pleased to add a
new book to this extensive collection, entitled *Colombia is Color,* that deals with the
extraordinary chromatic range of the country, its colors, that is, which, both in the
natural and social spheres, are beautiful and diverse.
In the case of this book, I have sought to afford readers an insight into the complex-
ity of Colombia by grouping its landscapes and people into what at first sight might
seem somewhat capricious categories, which nevertheless turn out to be highly
revealing ones. Color is, after all, one of the qualities that most closely defines
our reality. At the same time, it is my hope that this selection of photographs
may serve as a kind of multicoloured fan, a dazzling rainbow, to display the
true dimensions of a privileged place whose natural resources, fauna and
flora play a decisive role in its shape, culture and way of life. In other
words, I have tried to satisfy an old obsession of mine: to view
Colombia through the prism of color.

Benjamín Villegas

ALL THE COLORS OF
COLOMBIA

The diversity of colors you see in the daz-
zling landscape of Colombia is overwhelming. In
its 32 departments, powerful Western, Central and East-
ern Cordilleras and Atlantic and Pacific Ocean coasts, this im-
mense chromatic display presents itself with the forcefulness of a
great work of art, assuming the chromatic to be representative, of course.
Of all these colors, it is clear that green is the most outstanding one. Curi-
ously, this color is not found on the nation's flag, that symbol par excellence of a
country's identity, where the chromatic is most vividly highlighted. Its origin goes
back to March 12, 1806. It was on that distant and inaugural day, during the invasion
of the Venezuelan town of Coro, that a founding father of the Independence move-
ment, Francisco de Miranda, aboard the sailing ship or brigantine *Leandro*, raised, with
serene distinction, the yellow, blue and red tricolor for the first time.
There are many versions of the meaning of the national colors and the question still
rouses polemics. Beginning with the fiery words (colorful ones, we might say) which
Francisco Antonio Zea pronounced at the Congress of Angostura in 1819: "Our na-
tional flag, symbol of public liberties, of the redeemed America, should have three
stripes of different colors: let the first be yellow, to signify we nations who wish for
and love the federation; the second blue, color of the seas, to show the despots
of Spain that the immensity of the ocean separates us from its dreadful yoke,
and the third red, with the aim of making the tyrants understand that
instead of accepting the slavery which they have imposed on us for
three centuries, we would drown them in our own blood, swear-
ing to them war to the death in the name of humanity."
Other, less heated versions point out that the colors
yellow and red were taken from the Spanish

flag, while blue, to be sure, was introduced
to signify the distance from the mother country.
But there are still other versions, even one (which really
seems like bedroom gossip) which says that Miranda chose
those three colors as a gesture of gratitude towards his supposed
lover, the Empress Catherine the Great of Russia, yellow representing
her hair, blue her eyes and red her lips.
The official version, which is the one which has entered the popular imagina-
tion, says that the meaning of the flag is as follows: yellow represents sovereignty,
harmony, justice, and abundance and the richness of the soil; blue symbolizes the
sea, the two oceans on which Colombia has coasts; and red represents blood, life,
love, power, strength and progress.
In the latter there may be a key word. That word is richness or wealth. It may perhaps be
the one which best defines the chromatic qualities of the captivating Colombia landscape.
For that reason (and assuming once more that the chromatic is the representative), this
parallel between the country's colors and a work of art is not a farfetched comparison.
A comparison to a great fresco, we'd like to think. To a great fresco in which vari-
ous aspects converge: the different natural regions of the country, its many tourist
attractions, its abundance of musical rhythms and the distinctive gastronomy of
each place. And these colors, of course, have always been here, long before
anyone thought of them as a work of art. Our journey through them, at
least on this occasion, begins in the Caribbean region. Situated to the
north of the Andes, this vigorous prairie ends in the Sierra Nevada
de Santa Marta, which is the highest and most astonishing
mountain chain of Colombia. It boasts of the towering
Cristóbal Colon (Christopher Columbus) and

Simón Bolívar peaks, two veritable emblems of loftiness and purity, as its snow-capped summits attest. The Caribbean region is marked by the amazing delta of the River Magdalena and has an important seaboard, running from the gulf of Urabá to the gulf of Venezuela, which has the unique distinction of being the only place in the world where you can stand on a tropical beach and see snow-covered mountains nearby. Essentially flat, the region is characterized by its ecological variety: its ecosystems range from the lush jungle of the region around the gulf of Uraba to the impressive dry forests of La Guajira. The latter, which is also a department, is divided, in turn, into the upper, middle and lower Guajira. Desert for the most part, it is nevertheless bathed by sensuous rivers: the Ranchería, Carraipía, Palomino and Jerez. With a temperature between 27 and 30 degrees centigrade, La Guajira has a population made up of Mestizo, White, Indigenous and Afro-Colombian inhabitants. Among its best-known tourist attractions we find Los Flamencos Fauna and Flora Sanctuary, named after the pink flamingos who dwell there, which contains the unspoiled Manzanillo, Laguna Grande and Tocoramanes marshes; the Serranía de la Macuira National Natural Park, in no way a desert, where mountains, forests and natural springs merge to the delight of the *tigrillos* (lynxes), monkeys, deer, bluebirds and *guacharacas* (the Rufous-vented Chachalacas) who live in the zone; and the cabo or cape of la Vela, with noteworthy sites like el Faro, the lighthouse at its tip, and the Pilón de Azúcar (or Sugarloaf) hill, a place of mythological importance for the Wayuu indigenous people, who believe that when people die their souls pass through that beautiful place where wide golden beaches are framed by the deep blue of the sea.

As we travel through the Caribbean region we find other attractions: the famous coral reefs of the Rosario islands, the famous Ciénaga Grande de Santa Marta (one of the largest coastal wetlands in Latin America), the internationally-known Tayrona National Natural Park and the beautiful Los Colorados Fauna and Flora Sanctuary. And the fabulous music, without which no description of the region would be complete: the music of *gaitas* (traditional duct-flutes), drums and maracas, in the rhythm of the *cumbia* or *porro*. In the annual celebration of traditional dances, the women dress in long, colorful multilayered skirts, wear earrings, tie a kerchief round their heads and use striking makeup, while the men, for their part, dress in celestial white, with turned-up trousers and the famous "sombrero vueltiao" ("turned-brim" straw hat), an international symbol of Colombia which has struck the fancy of many foreigners, including Bill Clinton).

The cuisine of the place cannot be ignored either. One of the most typical dishes is the *sancocho* or fish stew, made up of thick pieces of *bocachico* or *sábalo*, with two big fish heads, plus *yuca* (manioc root), green and ripe plantain, coconut milk, lemon, sauce, ground thyme and pepper, a feast of color on the table. Having savored that treat, let's pass now from the Caribbean to the Andean region. While the Andes of Ecuador and Peru are a single cordillera with dizzying volcanic peaks, in Colombia, starting at the "nudos" (or nodes) of Pasto and Almaguer, near the frontier with Ecuador, they split into three: the western, central and eastern ones.

The Central Cordillera is separated from the Western one by a geological fault between the River Patía — the longest of the Pacific littoral of Colombia —

and the River Cauca, which is born in the magnificent Páramo (or high moorland) de Sotará, in the Colombian Massif, a strategic environmental area both on a national and international level by virtue of its being an "estrella hídrica" (literally a "hydric star"), that is, the country's major source of water, in the form of rivers which, in some cases, flow into neighboring countries.

The Eastern Cordillera, for its part, gradually bends towards the east, creating the basin of the River Magdalena, by far the country's most important water route and a great reserve of hydrocarbons. With a strategic, economic and cultural importance that runs from pre-Colombian times through the Spanish Conquest to the War of Independence, the River Magdalena has inspired legends and songs and been the site of famous battles. Perhaps the most memorable description of its tempestuous temperament is found in Gabriel García Márquez's novel, *The General in his Labyrinth:* "The heat became unbearable by day and the uproar of the monkeys and birds came to be maddening, but the nights were calm and fresh. The caimans remained motionless for hours on the sandbanks, with their jaws open to catch butterflies. Next to the empty hamlets you saw the fields of maize with skeletal dogs who barked at the passing boats and, deserted as it was, there were traps to hunt tapirs and fishing nets drying in the sun, but you didn't see a human being."

Finally, the Western Cordillera stretches to the northwest and reaches its highest point in Boyacá, forming the Sierra Nevada del Cocuy before crossing into Venezuela, where it becomes known as the Mérida cordillera. The human variety of the Andes parallels its great diversity of climates. It is a melting pot of different local cultures, with people from Antioquia, the two Santanders, Huila, Valle del Cauca, Nariño, Cundinamarca and

Boyacá. Long the most densely-populated part of the country, it is for that reason the one fullest of historical associations.

On the Cundinamarca-Boyacá high plains we thus find, among other examples, Guatavita Lake, the origin of the legend of El Dorado, the Gilded Man, protagonist of an ancient ceremony where fabulous amounts of gold were cast into its waters; Los Cojines del Zaque (an ancient Muisca ceremonial site which takes its name from two massive circular stones that may have been the thrones of their chiefs); the Pozo de Donato (a lake associated with many indigenous legends) and the historic Puente de Boyacá (Boyacá Bridge) where on August 7, 1819 the battle that secured the Independence of Colombia took place. It was on these same plains that the independent expeditions of three conquistadores, Gonzalo Jiménez de Quesada, Sebastián de Belalcázar and the German Nikolaus Federmann met up in 1538.

The region's rich soils produce potatoes, maize, wheat, barley and soy beans. Especially privileged is the department of Nariño, which has high temperatures, abundant rains and an exuberant vegetation. In Nariño there are also a variety of tourist attractions: the vibrant Las Lajas shrine, the peaceful and beautiful La Cocha lake (whose La Corota island is a wildlife reserve), the rugged Cumbal volcano with its icey lagoon, the mountainous maze of the nudo de los Pastos, the health-giving hot springs of Ipiales and La Cruz, the privileged seaside city of Tumaco, with its fabulous Bocagrande beach, the unruffled National Natural Park of Sanquianga and the renowned Galeras flora and fauna sanctuaries.

Among the local dishes you might enjoy are the *hervidos* or hot fruit punches with *aguardiente*, fruit juices with rice water, the *bizcochuelo nariñense*,

mostachones, hot chili with cheese, the *empanadas de añejo*, the *lapingachos* (potato and cheese patties), the meat of the *cuy* (a domesticated guinea pig) and rare loin with onions. The big celebration there is the Carnival of the "Whites and Blacks", which takes place in the first week of January.

Another department of the region, the Valle del Cauca, has been the birthplace of great artists: the painter/sculptor Omar Rayo, the theater director Enrique Buenaventura and the novelists Jorge Isaacs and Gustavo Álvarez Gardeazábal. The following passage from William Ospina's *Érase una vez Colombia* (*Once upon a time there was Colombia*, Villegas Editores) gives a good description of its topography: "You thus arrive at the descent towards the Valley of the Cauca, once more in the violent tropical light: wide prairies cut short in the distance by the vertical basalt walls of the cordillera, behind which rage the storms of the Pacific. This is valley of Jorge Isaac's [novel] *María*, which is not only a tale of romantic love, but a meticulous description of what the landscapes of this region of America were like at the end of the 19th century and the life of the great haciendas: their peasants, the hazards of jaguar-hunting, the struggle of human beings against the violent forces of nature, the horsemen who crossed swollen rivers at midnight or rode down through the canyons of the river Dagua, between enormous cliffs amidst mosses, ferns and the purest waters, going in search of the valley from the hidden pier of Buenaventura, the main port on the Pacific."

In the adjacent department of Huila, we find, among other wonders, the impressive archaeological park of San Agustín, which guards some of the most important pre-Colombian monuments in South America and was

declared a Patrimony of Mankind by the UNESCO in 1995. Huila is also the site of the Puracé [Volcano] National Natural Park, the Guácharos Cave National Natural Park (named after the nearly-blind oil birds which inhabit the cave), the Betania reservoir, the striking and peaceful desert of la Tatacoa and the temperamental snow-capped volcano, el Huila, the highest active one in the country. North of Huila is the department of Tolima, which prides itself on being the musical center of Colombia and is the site of many festivals of traditional music and dance, like the San Pedro fiestas en el Espinal, the San Juan ones in Natagima and Ibague's Colombian Folkore Festival and Garzón y Collazos Duet Contest.

Further north, passing Cundinamarca and Boyacá, we get to Santander, whose economy is based on petroleum, gold and electricity generation. Among its most popular tourist spots are the well-conserved colonial towns of Barichara and San Gil, with white-fronted, tiled-roofed houses, radiant sunsets and the quaint beauty of a picture postcard. Among its natural wonders we find the terrifying canyon of the River Chicamocha and the mountainous nudo de Santurbán, which turns into the Serranía de los Motilones. Of its local dishes it is worth mentioning the famous toasted ants (*hormigas culonas*), *mute* (a thick soup of mixed vegetables and meats cooked in a clay pot) and the *cabrito* and *pepitoria*, which feature goat's meat.

From a geographical point of view, to speak of its western neighbor, the department of Antioquia, is to speak of mountains: 80% of its terrain is ruggedly mountainous. And it is not in vain that its capital, Medellín, has been called the "Capital of the Mountain." Surprisingly, though, the remaining 20% is pretty flat. The immense Aburrá valley, the captivating

high plain of Santa Rosa de Osos, the attractive valley of Rionegro, the strategic and exuberant Paramillo National Natural Park and the picturesque Las Orquídeas National Natural Park are all worth a visit. Its highly-developed economy is based on mining, cattle and dairy farms and financial services. It is also a major producer of electricity, counts on gold, coal and platinum mines and has one of the continent's most advanced textile industries. A leader in transport, it boasts in Medellín of the modern José María Córdova airport, and the first Metro built in Colombia and Metrocable, which features both a surface and elevated rapid-transport system. Antioquia has played a leading role in Colombian culture. It is worth recalling such names as the painters Fernando Botero and Débora Arango, the sculptor Rodrigo Arenas Betancur, the writers Baldomero Sanín Cano and Manuel Mejía Vallejo and the philosopher Estanislao Zuleta, among many others. In music, it has been a rich source of *bambucos, pasillos, valses criollos* and songs, and the vitality of its theater is seen on the stages of the Metropolitano in Medellín, the Pablo Tobón Uribe and the Porfirio Barba Jacob.

To the west of the Andes, we find the Pacific region. Divided into two enormous zones by the cabo Corrientes, this Pacific coast strip runs from Ecuador to Panama and is bordered by the Western Cordillera. It is one of the most biologically-diverse places on the planet, rich in water resources, minerals and forests.

The flat jungle terrain is broken by the Baudó and Darién ridges and hollowed out by the basins of the rivers Atrato, Baudó and San Juan, strong-flowing with exceptional volumes of water. The climate is humid and tropical,

with the temperature ranging from 28 to 32 degrees centigrade. The moisture-laden winds from the Pacific, running into the mountains of the Western Cordillera, cause a rainfall so heavy that the region is one the wettest in the world, especially the department of the Chocó, where there are strong rains two-thirds of the year. The rains feed the turbulent rivers and create an equatorial-jungle vegetation. The Chocó also stands out for being the only Colombian department which fronts on both the Pacific and the Atlantic Oceans. The population is mostly Afro-Colombian and it has three natural parks whose natural wealth is nearly unparalleled: the Katíos, Utría and Tatamá.

Among the tourist sites which most strike the attention of foreigners, there are Nuquí, Quibdó and Bahía Solano, whose color contrasts are unforgettable. Other beauty spots include Humboldt Bay, Cape Corrientes, the Alto Puna and the Darien Gap, which was declared a Patrimony of Mankind and Biosphere Reserve by the UNESCO in 1983 because of its wealth of forests, animals and water resources. In the musical ambit, the Black communities of the Pacific have given us two remarkable genres: the *chirimía*, played by ensembles of clarinets, drums and cymbals in the Chocó and the music of the *marimba* (a wood or bamboo xylophone) bands on the southern shore, both of which blend European influences with rhythms and instruments of African origin. Local dishes include red snapper stewed in coconut milk, Creole chicken soup and *róbalo a la milanesa* fish stew, without forgetting the famous *borojó* juice, an exotic fruit reputed to cure cancer and an emblem of the Chocó. Continuing our tour, we arrive now at the crucial region of the Orinoquia, the basin of the Orinoco

River, which covers a good part of the eastern prairies of the country. Rich in cattle ranches and oil fields, it was the site of important battles in the War of Independence. One of its outstanding natural features is the world-famous serranía de la Macarena, a mountain ridge which (under a 1948 law) became the country's first national natural reserve and a natural park in 1971. Rising from the surrounding tropical prairie, its different thermal levels turn it into a privileged wildlife sanctuary, where the fauna and the flora of the Amazon, Orinoco and Andean regions converge, with an outstanding biodiversity and a large number of endemic species. It is a unique blend of jungle, forest, scrubland and light-filled clearings whose ecosystems have won the attention of environmentalists all over the world. Blessed with swift-flowing rivers and marvelous waterfalls and rapids, it is the home of the exquisite caño Cristales (known as the "stream of seven colors"), the Angostura rapids of the río Guayabero and caño Cafre, which is bordered by cliffs with ancient indigenous petroglyphs.

Also in the basin of the River Orinoco is the region known as the Llanos Orientales, or Eastern Prairies, a vast area whose ecosystems have a crucial importance. With two sharply contrasting seasons — rainy and dry — and an inter-tropical climate, it is a land of fertile soils ideal for large-scale stock-raising and agriculture. In *Amanecer llanero* (Dawn on the Llanos), the writer Getulio Vargas Barón described it in the following way: "Loving prairie, goddess of mystery, concubine of silence, the sun bathes you in light when the day dawns and at the hour of dusk places its loving kiss of colors on the emerald green of your savannas, where it merges into the august stillness of the night, watched over from the infinite by the zealously expectant moon."

The "llanero", the plainsman, is known,
above all, for his skills as a horseman, honed by
his work on the region's great cattle-raising haciendas,
a talent, which played a vital role in the battles which won the
country's Independence.

On these prairies, whose mixture of colors has no equal, the bravery
of the "llanero" is a matter of patriotic pride. The Llanos is the home of
the *joropo* – a traditional dance, also found in the adjacent prairies of Ven-
ezuela –, which is characterized by a quick triple-step with echoes of the waltz.
There is no doubt that it one of the purest expressions of the kind of music played
in colonial times.

The Llanos shades off into the Amazonia region, which covers 29% of the country's
area and is its least populated zone. In turn, it forms part of the formidable Amazon
jungle of South America, the world's largest forest, which covers parts of Venezuela,
Brazil, Ecuador and Bolivia, as well as Colombia. Among its splendid rivers, it is worth
mentioning the río Inírida, whose waters, when they debouch into the Guaviare in
the department of Guainía, lose their dark color (the result of vegetal deposits) and
take on a yellowish tone. Covered by dense jungle, crossed by long, powerful
rivers and dotted with innumerable lakes and swamps, the department of Ama-
zonas is also the homeland of a great variety of indigenous peoples, many of
whom still conserve their languages and customs despite the persecu-
tion suffered in the epoch of the Conquest and the Spanish Empire.

A place of exotic beauty, full of striking color and radiant sunshine,
it offers visitors such sights as the Cumare and Otare hills,
the exuberant sierras of Chiribiquete and San José,
and the internationally-known Amacayacu

National Natural Park. The food there is as exquisite and varied as the landscape: capon with squash, rice bread, chitterlings, minced meat and the now classic *guarapo*, a drink made of fermented sugar-cane or fruit. The staple in many places is fish, of which there are many kinds, which is usually accompanied by *fariña*, toasted manioc flour, a traditional indigenous food, sugar-cane tea (*aguadepanela*) and *chicha*, a drink made from fermented plantain. But that's not all. There is more, much more: *casabe* (cassava bread), river-turtle stew with potatoes, manioc, onion and coriander leaves and fish cakes made from *pirarucú* or *caimarón*. In this region, the typical dress consists, in the case of women, of a florid half-length skirt, white blouse and handcrafted belt and necklaces, while the men use a fisherman's outfit of white trousers, colorful shirt and shell, fang or seed necklaces.

This tour of Colombia could continue, of course: in fact it could turn into an absolutely endless journey, since there are so many other places to visit. However, for reasons of space, we have to limit ourselves, hoping that the ones shown in these pages will give the reader a good idea of what the country is like through a description of some of its most representative attractions. So, at this point, we must call a halt. It may not be superfluous to say that we have seen some impressive sights along the way, examples of the amazing diversity of the country's climates, fragrances, flavors and above all, the infinite colors of its chromatic range. There would be no way to cover them all, but perhaps the experience we have had, superficial as it may be, has given us the elements we need to recreate a great work of art. The fresco mentioned at the start, the picture of a warm, pleasant and colorful country, which everyone can elaborate in his imagination.

A color with a generally positive connotation, usually taken as the opposite of black. Among the range of favorable ideas associated with it there are ones like kindness, innocence, purity, safety, faith, cleanliness and virginity. Also associated with weight-loss, and dairy and low-calory products, white is related to hospitals, doctors and sterility. It is considered to be the color of perfection and a good start; this may be the unconscious reason why angels are usually shown as beings dressed in white. It is the color of snow, unblemished clouds and peace and is also linked to the idea of immortality. In etymological terms, its Spanish name, *blanco*, derives from the German word *blank*. White stands out in the impressive plumage of the albino peacock or the sombreros handcrafted from the fibers of the *iraca* palm. Likewise, the snow-capped Ruíz and Huila volcanoes and the frozen waterfalls of los Frailes cave in Boyacá.

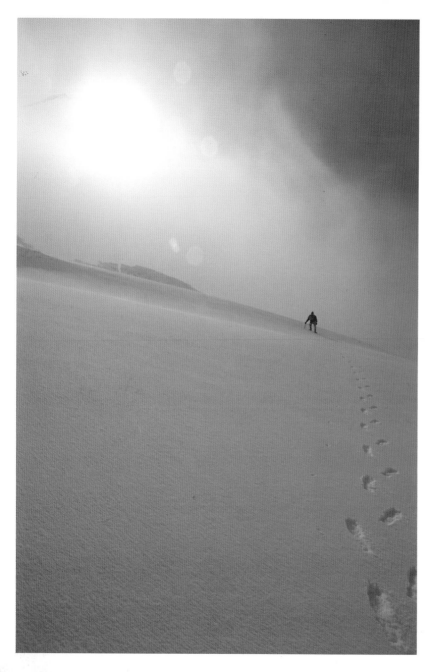

El Huila snow-capped volcano,
Central Cordillera

At 5 360 meters above sea level, it is the highest peak in the Cordillera, only surpassed in the country by the Sierra Nevada de Santa Marta. The different thermal levels of the National Natural Park named after it include ice fields, high moors and high and middle Andean forests, offering a great biotic wealth.

El Huila snow-capped volcano, Central Cordillera

It has four summits: the North Peak, Crest, Greater and South Peak. It is located in one of the rainiest zones of Colombia's mountain system and is the source of the famous River Paez, which runs along the eastern flank of the Central Cordillera. Inactive for years, this giant has recently awakened again.

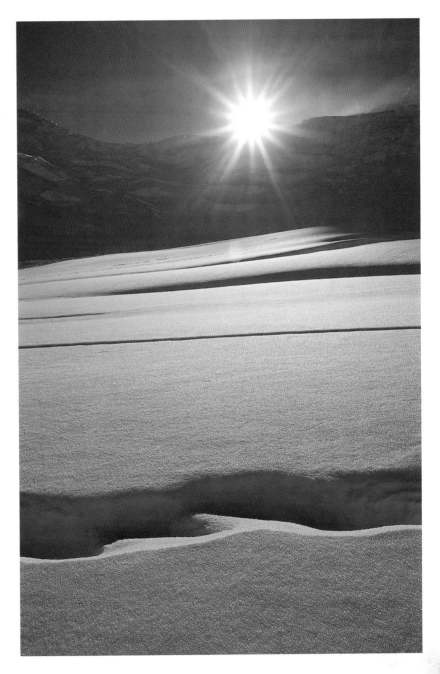

Galeras Volcano, Nariño

The first recorded eruption of this volcano, which is still active, took place in 1580, 43 years after the founding of the city it overlooks, San Juan de Pasto. There is a flora and fauna sanctuary on its slopes. An inner cone with several craters rises from an immense circle on its summit.

El Ruiz snow-capped volcano, Central Cordillera

Known as the Nevado del Ruiz or Mesa de Herveo, it rises to 5 400 meters above sea level and being relatively easy to climb, is the country's best-known and most frequently visited high mountain. It has two adventitious craters: the Olleta and the Alto de la Piraña. The main crater, known as the Arenas, is 150 meters deep and ice-free. The Ruiz is still an active volcano.

Tropical forest cascade, Quindío

Colombia is extraordinarily rich in water resources, due to its abundant rainfall and mountainous geography, among other factors. It has a large number of major rivers, with impressive flows and volumes of water. Its annual rainfall, estimated at 2 750 mm, is three times the world average.

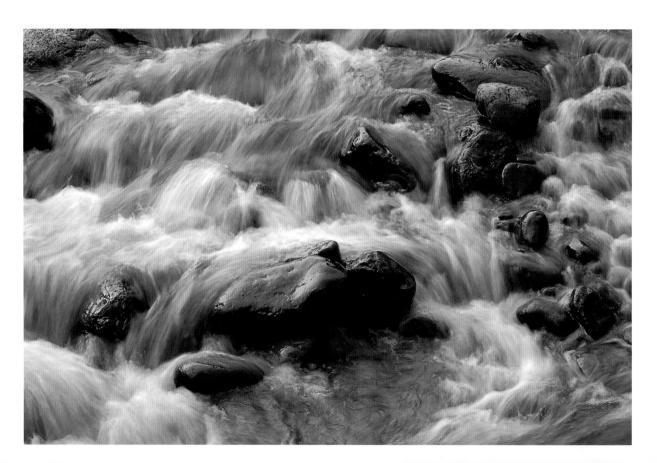

Cascade on the snow-capped Huila Volcano

This enormous mountain is also the birthplace of rivers vital to the region's flora and fauna and human inhabitants. Some of the streams and rivers flowing down it become tributaries of the River Cauca, while others, like the Saldaña, are responsible for half the volume of water of the River Magdalena.

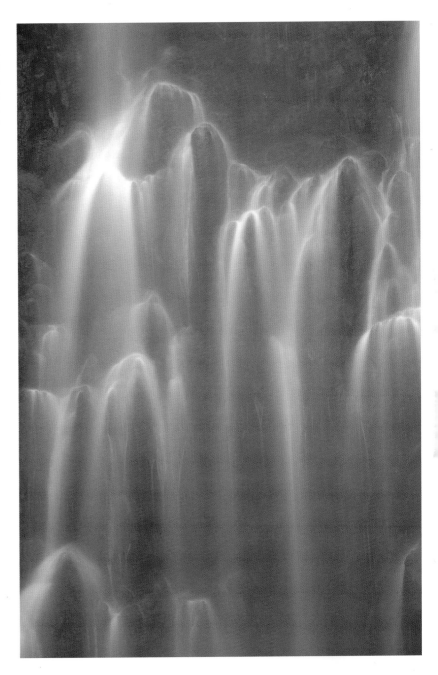

Monserrate Mountain, Shrine of the Fallen Lord, Bogotá

The tutelary peak of Bogotá, Monserrate, whose summit is at 3 131 meters above sea level, is crowned by a church originally built in 1657, though its current architecture is modern. Some climb it on foot; others take the cable-car or funicular train. It offers visitors unparalleled views of the city.

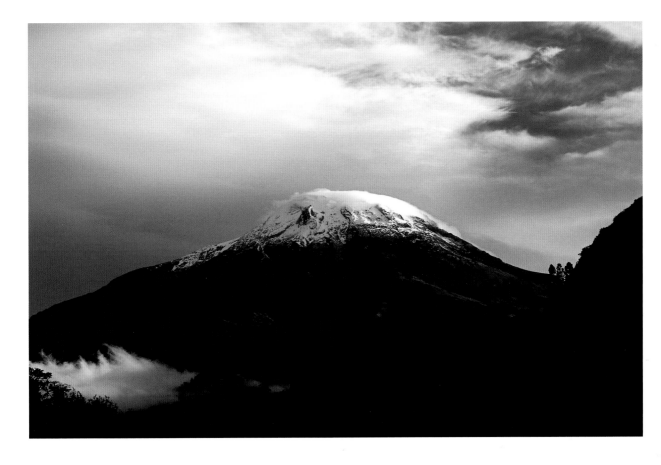

Snow-capped El Tolima Volcano

Rising to a height of 5 215 meters, it is one the country's most beautiful peaks, though its steepness makes it difficult to climb. It forms part of the Ruiz-Tolima volcanic massif of the Central Cordillera, which features the snow-capped mountains of Quindío (5 150 meters), Santa Isabel (5 100 meters), Cisne (5 200 meters) and Ruiz (5 432 meters), among others.

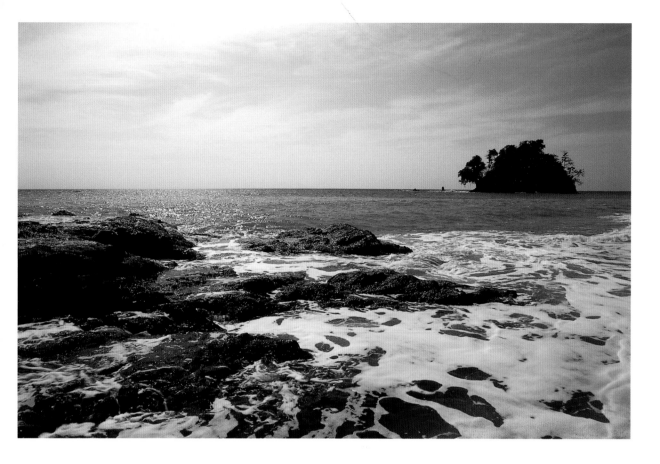

Beach at El Valle, Chocó

This village lies between Bahía Solano and the Utría National Natural Park. This delightful corner of the Colombian Pacific offers memorable landscapes, beautiful beaches and, during some months of the year, a sight of migrating shoals of hunchback whales.

Tairona National Park, Department of Magdalena

Located on the shores of the Caribbean, by the foothills of the Sierra Nevada, it has a land area of 12 000 hectares and a sea area of 3 000 hectares. It is rich in exotic flora and fauna and is an archaeological site of world importance, with relics of cultures ranging from 15 000 year-old nomadic hunters to the high civilization of the Taironas.

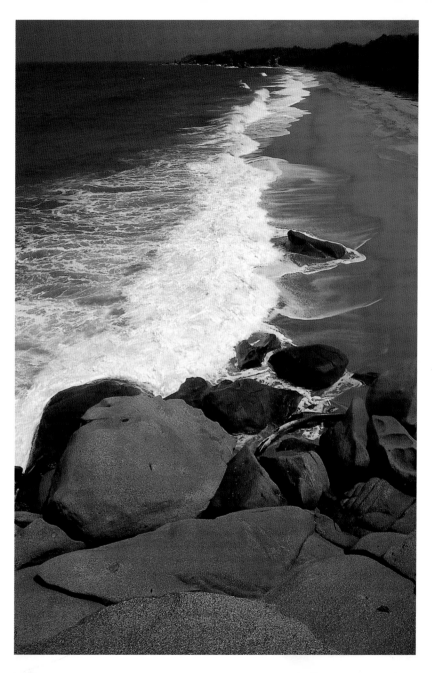

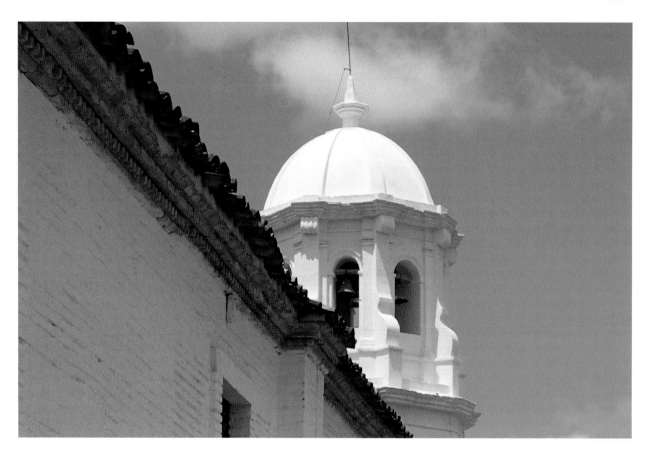

Santo Domingo Church, Popayán, Cauca

The current church, dating from 1741, was built on the ruins of the original
one built in 1588 and restored after the 1983 earthquake. Its doorway is
in the rococo style and the rest of the building and its tower, designed
by the Spanish architect Antonio García, are neo-Grenadine baroque.
The city's famous Easter Week procession begins at this church.

Manaure saltworks, La Guajira Department

This part of La Guajira, situated on the Caribbean, is a dry, rocky plain dotted with sand dunes and salt lakes where the Wayuu indigenous people extract salt. Manaure produces 90% of the domestic and industrial salt consumed in Colombia.

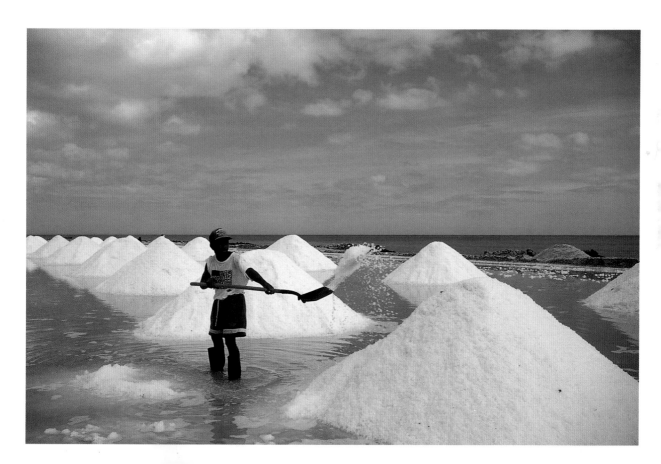

Condor on the snow-capped Puracé Volcano, Cauca

The world's largest bird, the condor, weighs up to 12 kilos and its wings, extended in flight, reach 3 meters. It may reach an age of 70 years. The males can be distinguished from the females by the crest on their heads. It has been regarded as a sacred animal since pre-Colombian times.

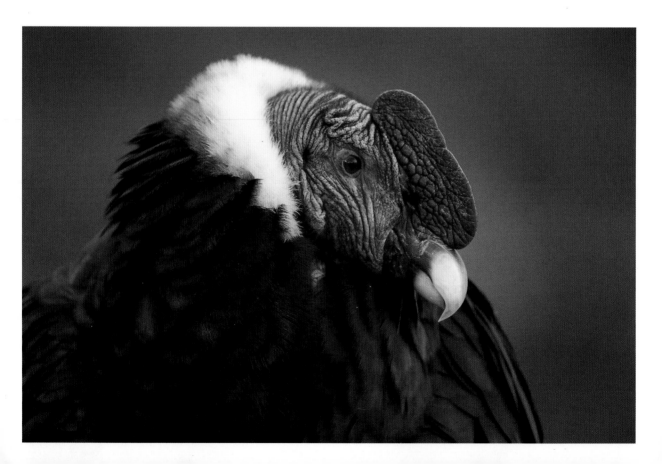

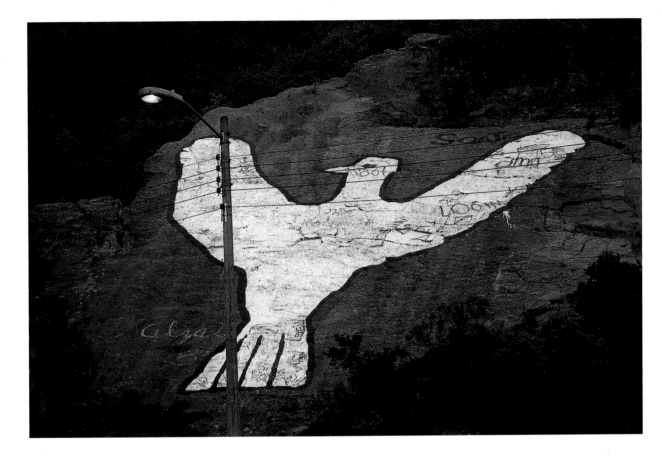

Dove of Peace, street art in Bogotá

This dove was one of thousands painted during "Artists for Peace Day," celebrated on August 26, 1984. This one is still visible on the eastern ridges of Bogotá along the road to La Calera and similar ones were painted in cities like Neiva, Medellín and Barranquilla.

Macaw, Leticia, Amazonas

The macaw or *guacamaya* (*Ara sp*), a bird native to the American tropics, lives in jungles, forests and plains near rivers and streams, and feeds off fruits, nuts, insects and plants. There are two varieties (*Ara macao* and *Ara ararauna*), the red and blue, depending on its plumage.

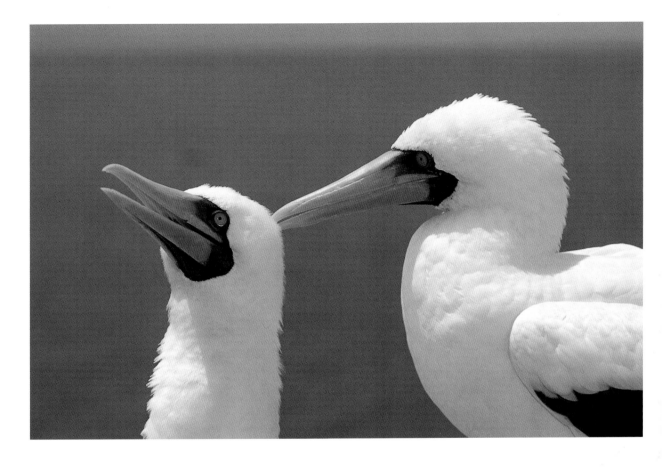

Masked Booby couple, Malpelo Island

This Pacific coast island is the site of the world's largest breeding colony of these birds. Birds dominate the island's fauna, with 60 different species identified. Malpelo Island is the cusp of a submarine mountain range called the "Dorsal de Malpelo," with slopes that descend to a depth of approximately 4 000 m.

Colonial astronomical observatory, Bogotá

This was the headquarters of the late-colonial "Botanical Expedition" which made a scientific survey of Colombia, headed by the Spanish savant José Celestino Mutis. It has an octagonal shape, three sections and a vaulted ceiling. The observatory, located within the precincts of the presidential residence, the Casa de Nariño, was run by the scientist Francisco José de Caldas, martyr of the Independence movement.

Central Cemetery, Bogotá

Inaugurated in July 1838, it enabled the city to do away with the practice of burying the dead in churches. It was designed by José Pío Domínguez and Rafael Álvarez and a chapel was added in 1840. Declared a National Monument in 1984, part of its original terrain now holds the Parque del Renacimiento or Renaissance Park, opened in the year 2000.

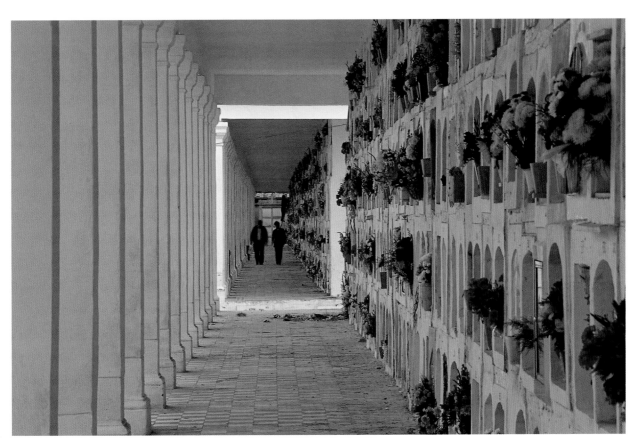

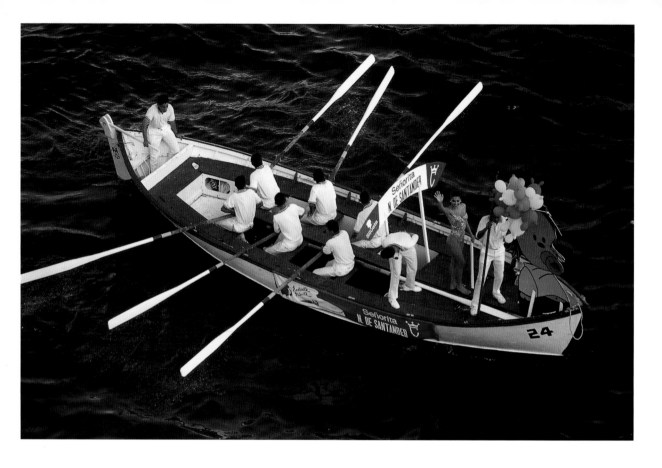

Whale Boat Procession, Cartagena Bay, Department of Bolívar

Two traditional fiestas take place in Cartagena in November: the cel-
ebration of the city's independence and the National Beauty Contest.
One of the colorful features of the latter is the appearance of the
candidates in whale boats rowed by cadets from the Naval School,
which began in 1970.

Religious procession, Pamplona, Norte de Santander

Along with those of Popayán and Mompox, this is one of the country's most traditional religious celebrations. It features groups of incense-carrying "sisters," "knights of the cross," local authorities, musical bands and high school students in formal dress. An International Festival of Sacred Music complements it.

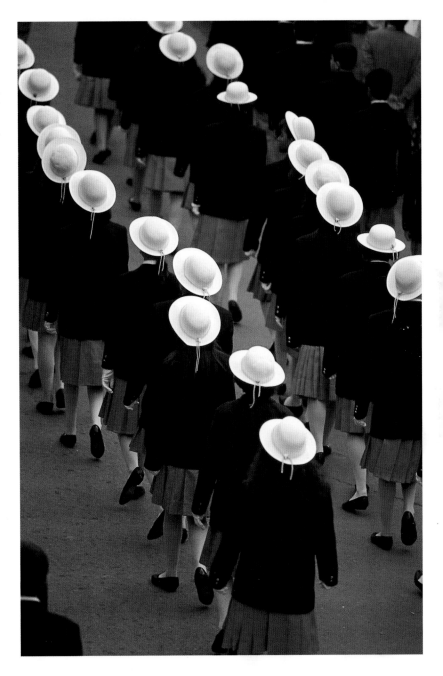

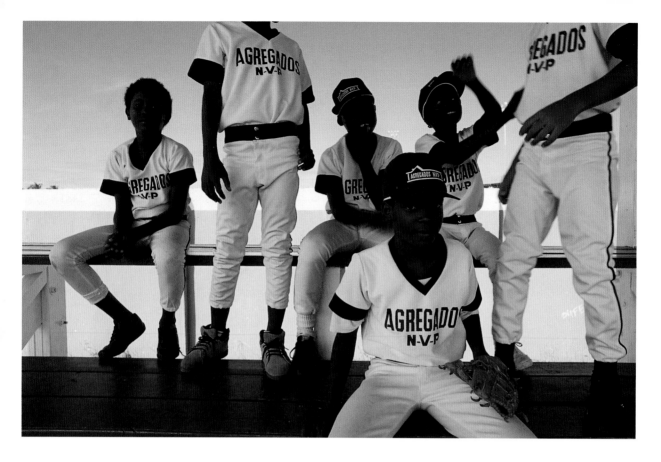

Young baseball players, Island of San Andrés

The Archipelago of San Andrés, Providencia and Santa Catalina lies
at a distance of 720 km northwest of the Caribbean coast of Colom-
bia. Although it was discovered by Spain, its population descends from
English Puritans and Jamaican woodcutters. 70% speak both English
and Spanish, along with patois (*patuá*).

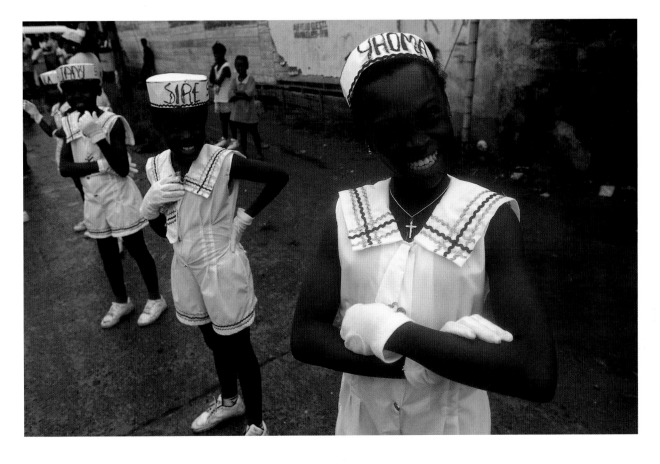

San Pacho Fiestas, Quibdó, Chocó

Quibdó, located on the banks of the River Atrato, was founded in 1648. Its patron saint is St. Francis of Assis. Its fiestas, celebrated between September 20th and October 5th, combine religious and carnival features, the latter including a fancy dress known as the *caché* used in a procession which marches to the sound of the traditional *chirimía* band of the Chocó.

Happiness and intelligence are some of the values symbolized by the color yellow. Associated with the luminosity of the sun, it brings joy and stimulates the mind. The painter Vincent van Gogh obsessively used yellow in the final stage of his work. It was also the only color, the Argentinian writer Jorge Luis Borges was able to distinguish when he became blind. Spontaneous and changeable, the use of the color is recommended to summon up joyful feelings. Psychologists say it helps to strengthen the memory. In many cultures it is the symbol of the deity. The Spanish word for it, *amarillo*, comes from the Latin *amarellus*, which derives, in turn, from *amarus*, "bitter." Yellow is the dominant color in the twilights of Barichara, the tower of the aerial cableway in Manizales, the 17th century fortress of San Felipe in Cartagena and the "Battle of Flowers" of Barranquilla's Carnival. It is also seen in the senecio flowers of the Cocuy and the front of the Santa Bárbara church in Mompox.

Jaime Duque Park, Sopó, Department of Cundinamarca

This theme park, founded in 1983, has, among other attractions, a replica of the Taj Mahal, a museum of mankind, a diorama of the Divine Comedy, a giant map of the country, dioramas of children's stories, a display of the world's national costumes, a mythological fountain, monuments honoring God and the nation and the Condor building.

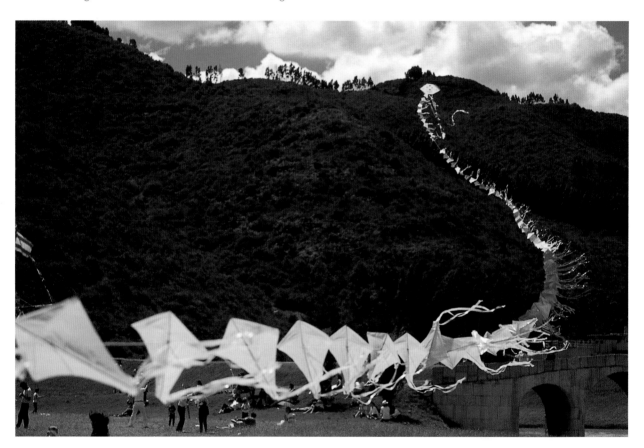

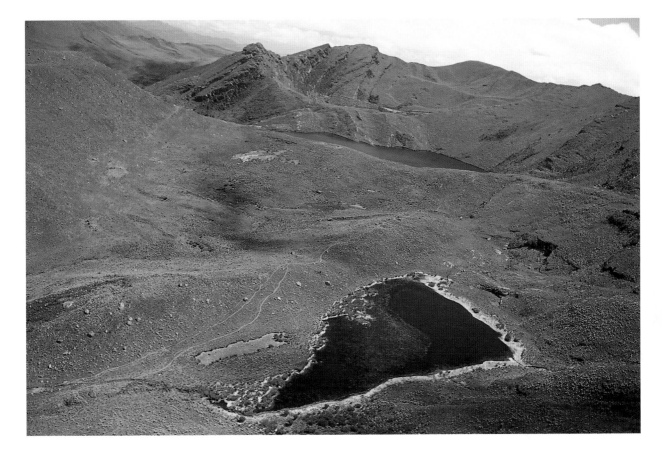

Siecha Lakes, Cundinamarca

Located north of the Chingaza paramo or high moor, in the municipality of Guasca, it was here, following an attempt to empty one of the lakes, that the famous gold balsa raft, now displayed in the Gold Museum, was found. Its clean air, beautiful scenery and challenging hikes make it a favorite place for ecological excursions.

Parque de los deseos, Medellín, Antioquia

Literally the "park of wishes," this interactive museum aims to give visi-
tors a better understanding of scientific subjects like astronomy, natu-
ral phenomena, water, energy, communications and the environment.
It was designed by local universities and the foundation run by the
Medellín Public Services Company.

Clock tower, Cartagena, Department of Bolívar

Built on the main 18th century gateway to the walled city, the present tower was constructed between 1886-1888 and designed by Luis F. Jaspe. It has a quadrangular base, an octagonal second story with four clock faces and four ogival windows and the belfry, topped by a slender spire.

Frailejón-flower, páramo de Sumapaz

The *frailejón* (*Espeletia congestiflora*) is a plant native to the paramos or high moorlands, of which the Sumapaz is the largest in the world. Due to the retentive capacity of their spongy vegetation, these ecosystems have a vital environmental importance and are the source of most of the country's water.

El Cocuy, Boyacá

Situated at the foot of the Sierra Nevada del Cocuy in northwest Boyacá, this village conserves most of its colonial and republican-era architecture as well as many of its traditional customs, like the open-air saint's day celebration, neighborhood festivals, cockfighting, skittle and pitching games and the cooking of regional dishes.

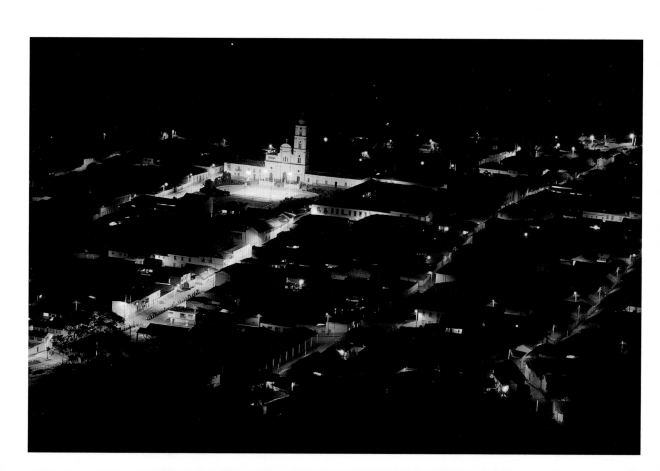

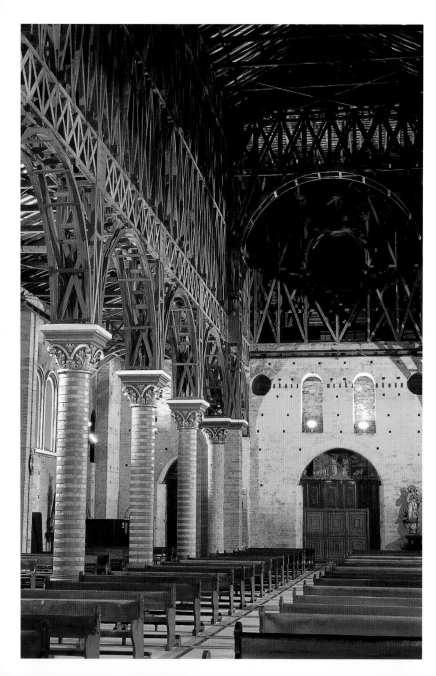

The Cathedral of Pereira

Located on one side of the plaza de Bolívar, the cathedral of Our Lady of Poverty, originally built in 1875, was restored after an earthquake in 1999. Its structure features exposed brickwork, with an elaborate framework, made of 12 000 pieces of wood, which supports the cupola.

Chapel of Salt, Nemocón, Cundinamarca

This impressive, 80 meter-deep site was dug out of a salt mine which was originally worked by the pre-Colombian Chibchas. It is a cultural complex made up of reception rooms, fountains, a dance hall, a salt cascade and a wishing well.

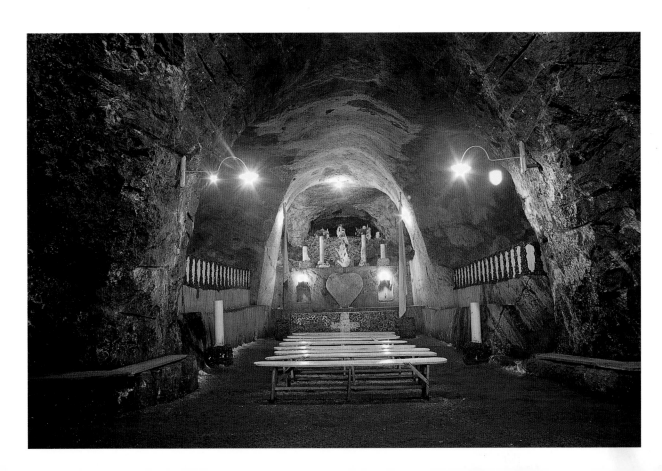

Reproduction of pre-Colombian jewelry

An appreciation of the artistic value of pre-Colombian goldwork began in the 1930's in Colombia, but reproductions of the original pieces did not come into being until the 1970's. Nowadays such replicas are exported to different foreign countries.

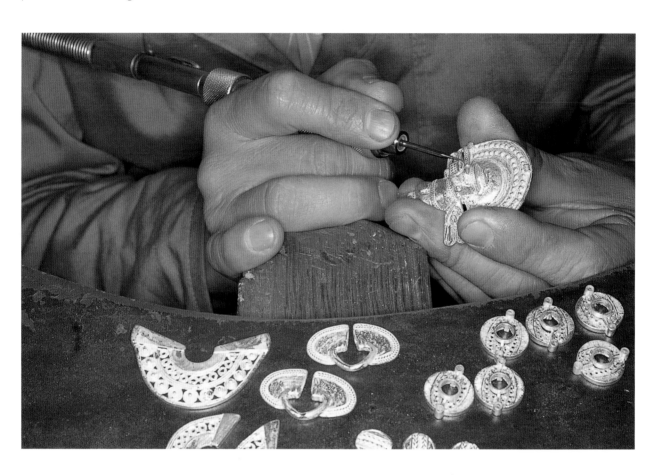

Cathedral of Manizales,
Department of Caldas

Work on this basilica, designed by Julien Polty, began in 1928, two years after the first cathedral was destroyed by a fire. Built in an eclectic style, it has a strong Gothic inspiration, seen in the pointed, crossed arches which support a Byzantine-style cupola.

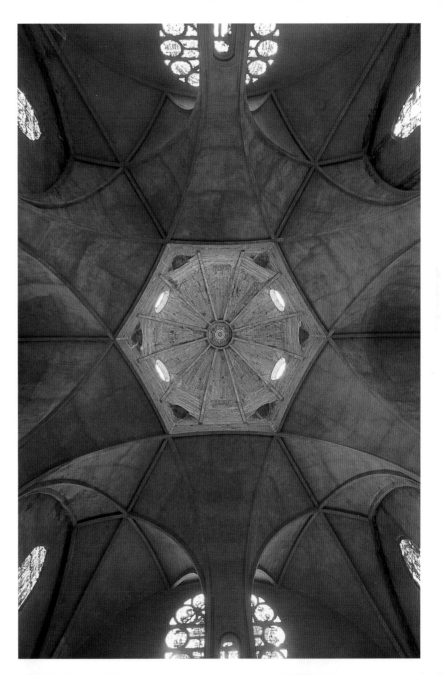

The Herveo Tower, Manizales

This was part of the aerial cableway which linked Manizales with Mariquita and the River Magdalena, the world's longest in its day, with a span of 62 km and 376 towers. This one, the only built in wood, originally stood in the town of Herveo and was later disassembled and rebuilt in Manizales, where it has become an emblem of the city.

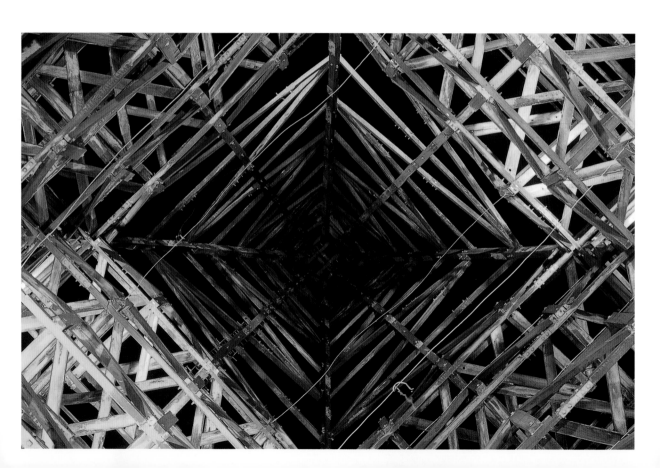

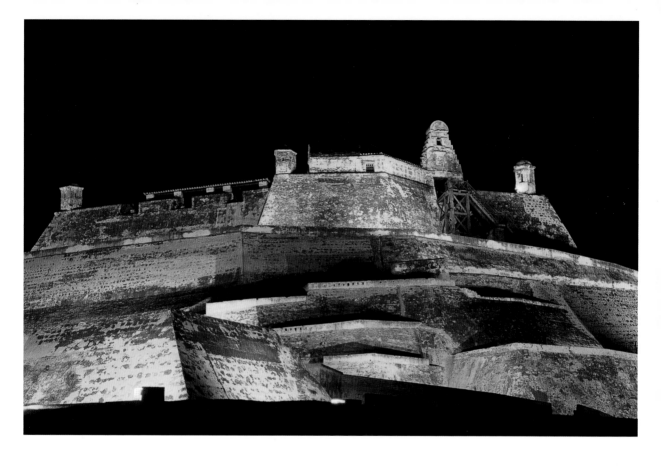

The Castillo de San Felipe fortress, Cartagena

This was the key part of the most formidable defensive complex ever built by Spanish military engineers in the New World. It features an intricate system of tunnels, ramps, trapdoors and escape routes. It thwarted any attempt to invade the city, either by land or from the Bay of Cartagena.

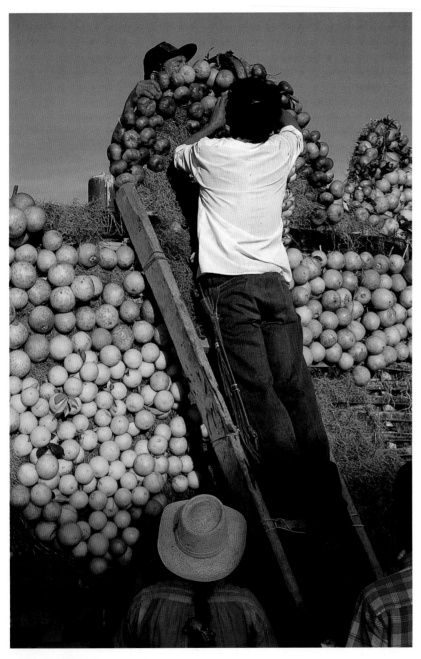

Corpus Christi Celebrations in Anolaima, Cundinamarca

This town, located in the territory of the Anolayma indigenous nation, was founded by the conquistador Gonzalo Jiménez de Quesada when he was en route to the savanna of Bogotá in 1538. Its Corpus Christi festivities feature processions, floats and exhibitions displaying the products of its rich soils, which have earned it the title of the "Fruit-growing capital of Colombia."

Hacienda in Simijaca, Department of Cundinamarca

Known as the Hacienda Aposentos, it was designed by the colonial friar Domingo de Petrés, also responsible for the Cathedral of Bogotá. Though parts of it were rebuilt in the "republican" style of the mid-19th century, it conserves some of its original colonial features, like the large roofs of ceramic tiles and the inner courtyard.

Barichara, Department of Santander

Located on the Yarigüies mountain range, part of the historic "Comunera" province which also includes the nearby colonial village of San Gil, Barichara has one the most beautiful and best-conserved town centers in the country, most of which dates back to the 18th century. It is known for its red-orange soils and the work of its stone-carvers.

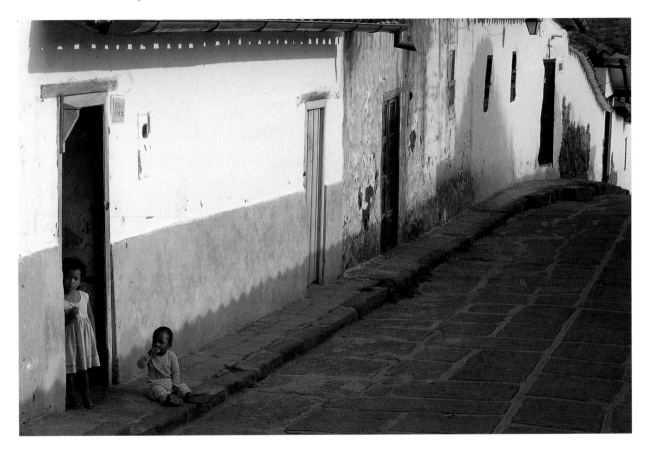

This ecclesiastical complex is made up of a small funeral chapel, the church and the beautiful tower, built in 1749, which has an octagonal floor-plan. Its highly ornamented ground floor gives way to a balcony on the second and is topped in turn by a third level with circular windows and a columned fourth storey which supports a crown-shaped cupola.

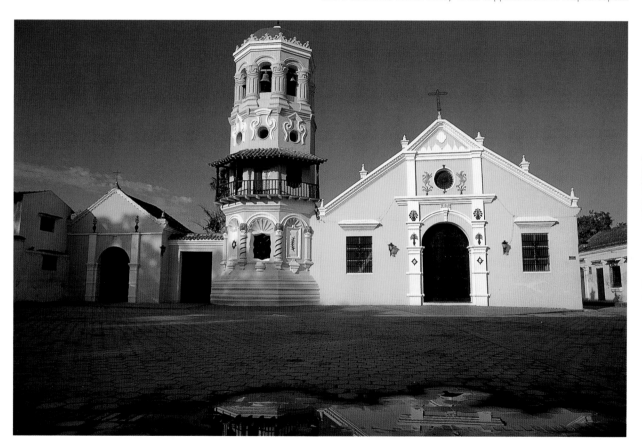

Street scene on the "Séptima" in Bogotá

The Avenida Séptima, between the Plaza de Bolívar and Calle 26, has long been the place for a leisurely stroll known as the "Septimazo." Recent mayors of Bogotá have sponsored the holding of cultural events there and closed off the street to traffic on holidays, which along with the hawkers and performers turn it into a colorful family outing.

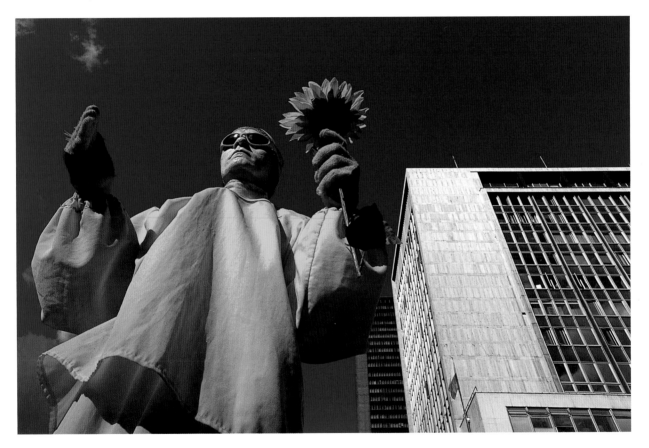

San Pacho Fiestas, Quibdó, Chocó

The first fiesta dates back to 1648, when Franciscan missionaries organized a procession of balsa rafts carrying a statue of St. Francis. Nowadays it is a mixture of carnival and religious celebration. The parades wind through the city's neighborhoods in an uproar of music and dancing which also includes a humorous mockery of current events.

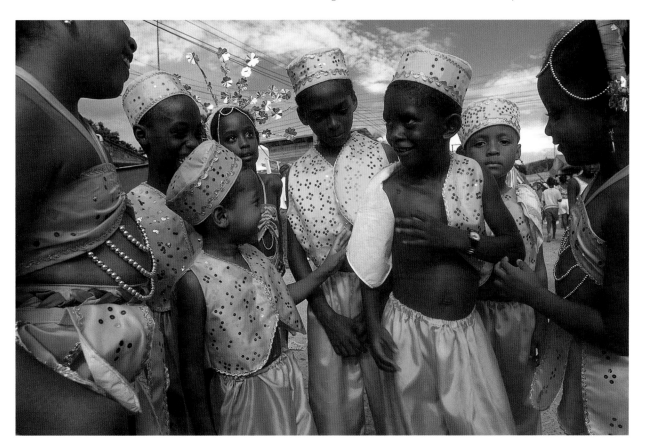

Kokoi poison frog, Chocó

A member of the dendrobatid family, known for its vibrant colors which warn predators of the presence of poison in their skins, this frog has the world's most potent neurotoxin. This substance, known as a batracho-toxin, may be useful in the treatment of neurological illnesses.

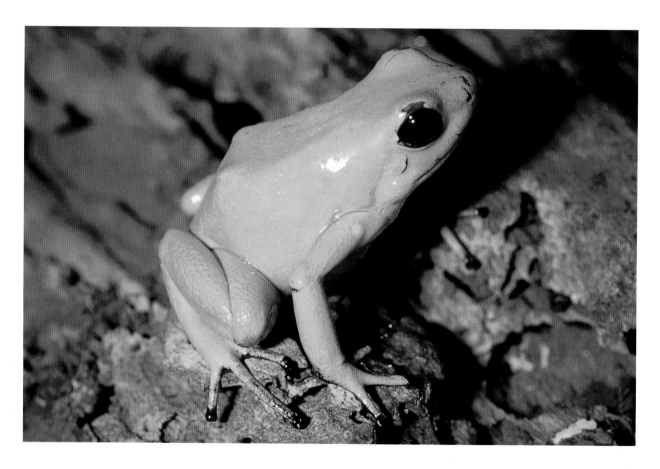

Owl of the western Andes

The Asio genus includes the eared owls, which are characterised by feather tufts on the head, which have the appearance of ears. They are medium-sized, 30-46 cm long and have large wings. These tropical Stygian owls are mostly sedentary and hunt at night for rodents, small mammals and certain birds.

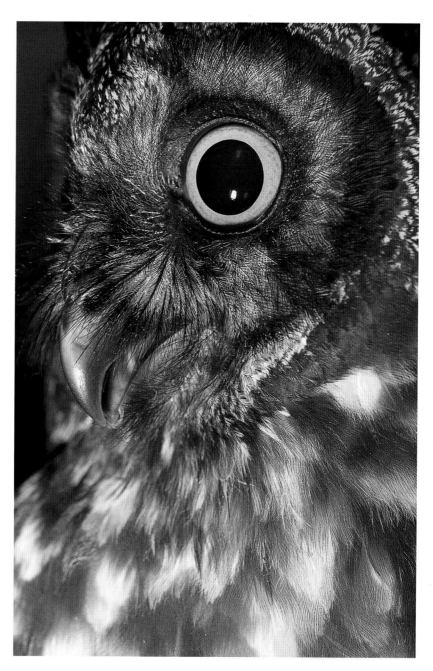

Wheat fields, southern volcanoes, Department of Nariño

The slopes of the great volcanoes of Nariño are densely populated and intensely cultivated. Ancient deposits of ash make their soils highly fertile. The beneficial effects of the volcanic terrain overweighs the danger of eruptions, which are infrequent.

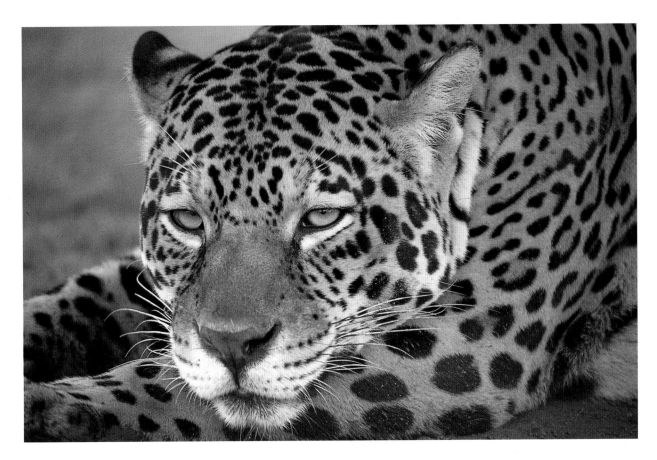

Jaguar (Panthera onca)

The largest feline in America, the jaguar is muscular and robust, with relatively short legs and a large head. Its jaw is the most powerful one of the genus and its pattern of spots is unique and unmatched. The males grow to a length of 1.72 to 2.41 meters while the females are a little smaller.

Combining the energy of red with the joy of yellow, the color orange stands for enthusiasm, attractiveness, creativity, determination, success, pluck and stimulation. It is a color, which produces a feeling of warmth; hence it is associated with the tropics. Unaggressive and related to a healthy diet and a good appetite, seeing the color orange produces the sensation of more oxygen being supplied to the brain. Friendly and stimulating, it has an active, radiant and expansive force. Although it is the color of meat and the comforting hearth, it may also express instability and dissimulation. Etymologically, its Spanish name, *naranja*, derives from the Arabic word *narang*. Orange is the color of the island of Gorgona, the jaguars who prowl through the land of Caquetá, the daily work of the Paz del Río steelworks, the tiled roofs of the colonial houses of Cartagena and likewise Bogotá's Summer Festival and the cerros orientales, the eastern mountain flank of Bogotá.

Royal Condor

The *condor real* is a rare bird which soars over the lands of Colombia and is also found in other parts of Latin America, from Mexico to northern Argentina. It lives in heavily-vegetated and semi-arid zones and in marshy terrains and prairies near forests.

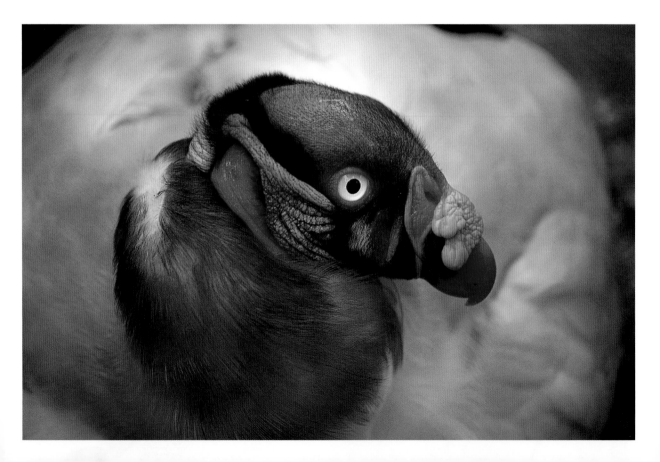

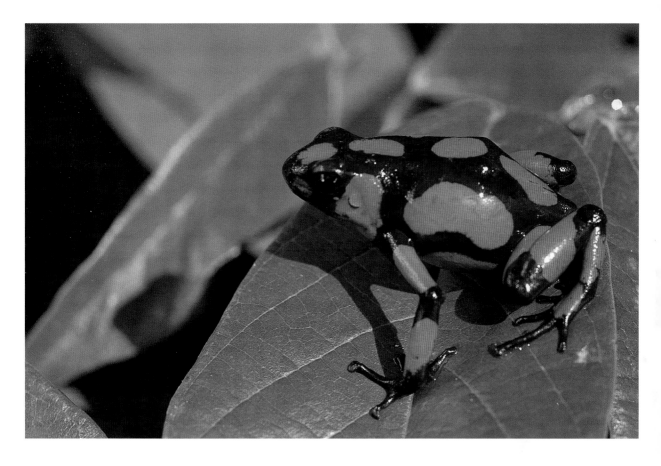

Poison frog, Chocó

The kokoi, also known as the harlequin poison frog, is characterized by the bright colors of its body — yellow, orange, red, white and blue — which serve to warn away predators. They live in the Chocó region of Colombia and western Ecuador.

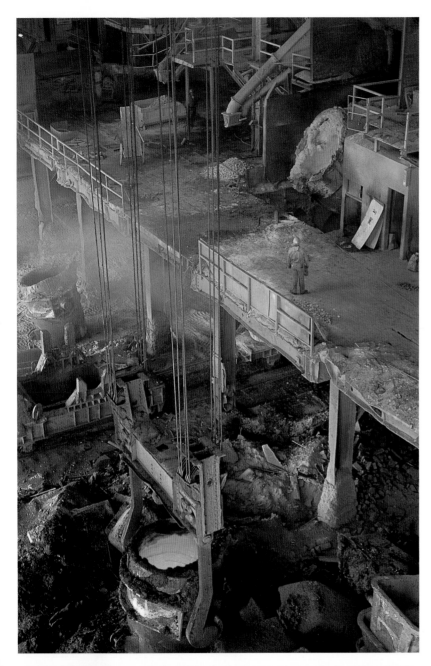

Paz del Río steelworks, Boyacá

The equipment in this plant relies on the iron and coal mines in the town of Paz de Río, the coal from Samacá and the limestone from Belencito. It lies at a distance of 70 km from the Department's capital, Tunja, at an altitude of 2 400 meters above sea level and has an average temperature of 18 °C.

Galeras Volcano, Nariño

This volcano forms part of the Galeras Volcanic Complex. It is located in the Node of the Pastos in the Department of Nariño at an altitude of 4 276 meters above sea level and lies 9 km west of the departmental capital, San Juan de Pasto, the lights of which are seen in the background.

Río Vichada, Department of Vichada

This river begins in Puerto Gaitán, in the Department of Meta, in the eastern prairies, at the juncture of the rivers Planas and Tillavá. More than 600 kilometers-long, it flows, from west to east, through the Department of Vichada, debouching into the Orinoco. The region is rich in fish and cattle.

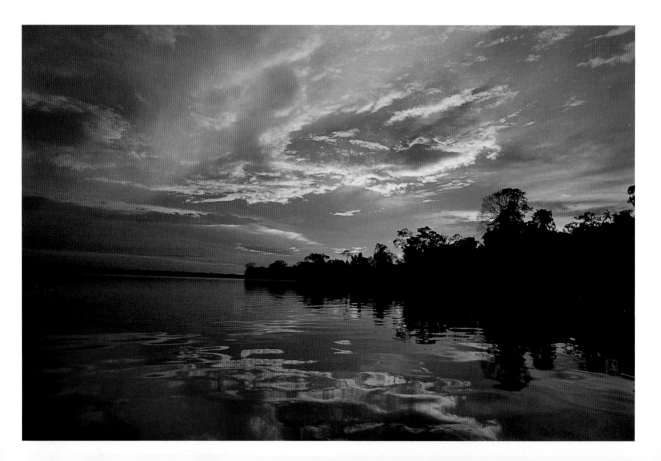

Naboba Lake, Magdalena Department

Lying at an altitude of 4 540 meters above sea level between the different massifs which make up the Sierra Nevada de Santa Marta, it is a sacred site for the local Ijka indigenous people, who call it "chundua," which means the place where human life begins and to which the soul returns after death.

Dance of the *garabato*, Carnival of Barranquilla

This dance is one of the emblems of the Barranquilla Carnival. It is a folkloric depiction, full of irony and sarcasm, of the struggle between life and death. The women dancers wear a long skirt with ruffles, which bear the colors of the flag of Barranquilla — yellow, green and red.

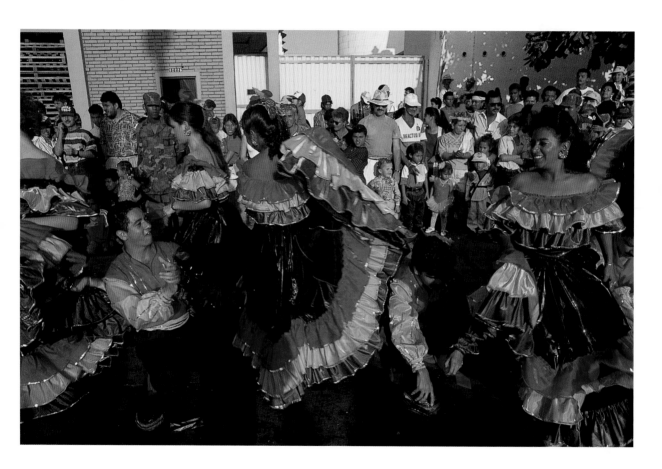

Dusk in Bogotá

The fall of evening casts a special light on Bogotá as the sun filters through the clouds and descends behind the mountains. Traditionally called "the sun of the deer," it creates haunting textures and shadows and gives the streets, roads and houses a memorable tonality.

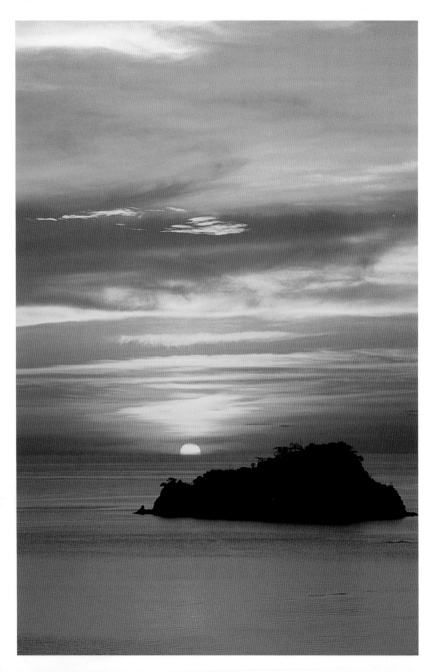

El Morro island, Santa Marta, Magdalena

This is a prominent natural feature of the city, with strong historical associations. Its ancient indigenous inhabitants would go there to observe the night sky, believing that the sun and moon coupled in the interval between sunset and moonrise and the fruit of their love were the stars and fireflies.

River Magdalena

This is the main fluvial artery of Colombia and its basin extends to 18 of the country's departments. Flowing south to north, it crosses nearly the whole of the country, from San Agustín in the Department of Huila to its mouth in the Caribbean, at a place known as Bocas de Ceniza, located 22 km from Barranquilla.

San Fernando Bocachica fort, Cartagena

This fascinating fortress — one of the city's most impressive works of military architecture — stands a few meters away from the beaches of Bocachica, at the southern end of the canal, on the Island of Tierrabomba. Its construction dates back to 1753, when it replaced the San Luis Fort.

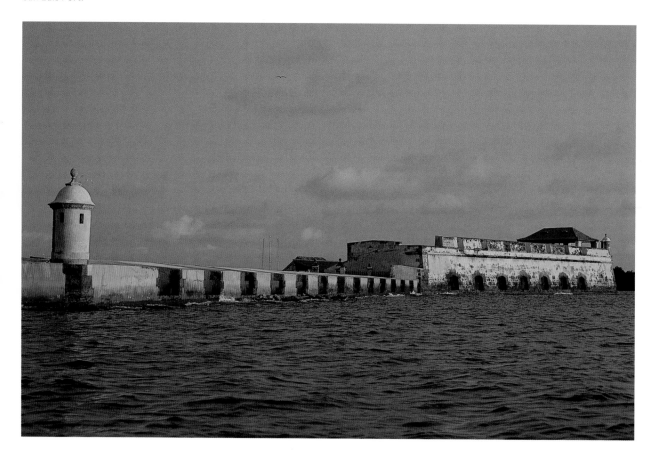

Wayuu Festival, Uribia, La Guajira

This is the most important gathering of the Wayuu indigenous nation, where they meet to reaffirm their identity, conserve their customs and promote their ancestral traditions. It closes with the election of the *Majayut* — the Wayuu woman — chosen for her beauty and knowledge of their culture.

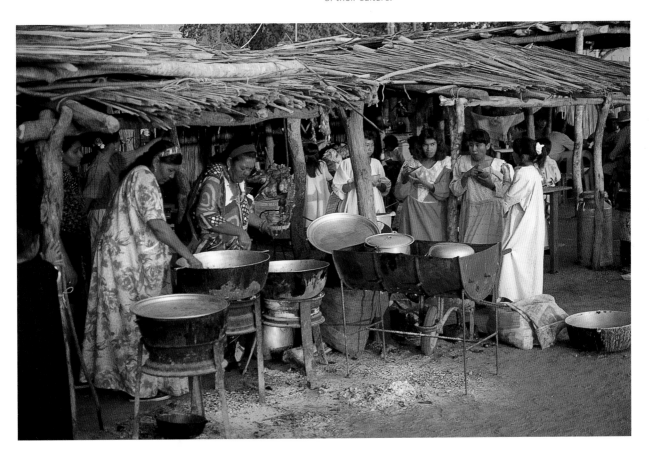

Varieties of Boyacá squashes

The ancient Chibchas of the high plains of Boyacá grew maize, potatoes, sweet potatoes, *arracacha*, beans, chili peppers, quinoa, *cubios* and *hibias*, sweet manioc and squashes and pumpkins: most of them ingredients of the typical "cocido boyacense".

Bogotá Theater Festival

For the past twenty years, Bogotá has been the seat of the Ibero-American Theater Festival, which turns the city into a giant stage for theater companies from all over the world. In terms of the number of participating countries, it is the world's largest.

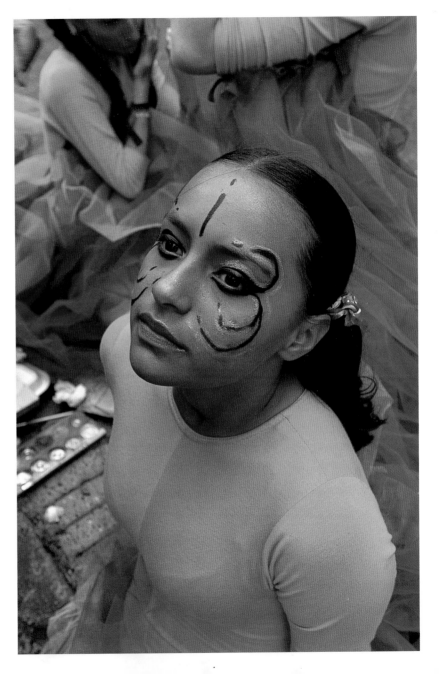

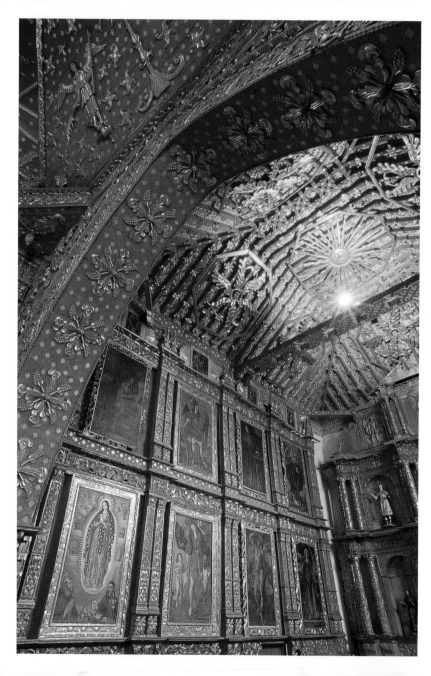

Santo Domingo Church, Tunja, Boyacá

Built in the 16th century, it is one of the best examples of colonial architecture in Latin America, with a great artistic and cultural importance. It has a four-slope roof, with a half-barrel-vault ceiling. Its interior, which features the Rosario chapel, is rich in wood-carvings and gold leaf.

El Sagrario Chapel, Bogotá

This is a very fine example of the neo-Grenadine baroque style. It was constructed between 1660 and 1689. It houses colonial-era paintings by Colombia's best-known religious artist, Vásquez de Arce y Ceballos. Its main altar is made of ebony, marble and tortoiseshell.

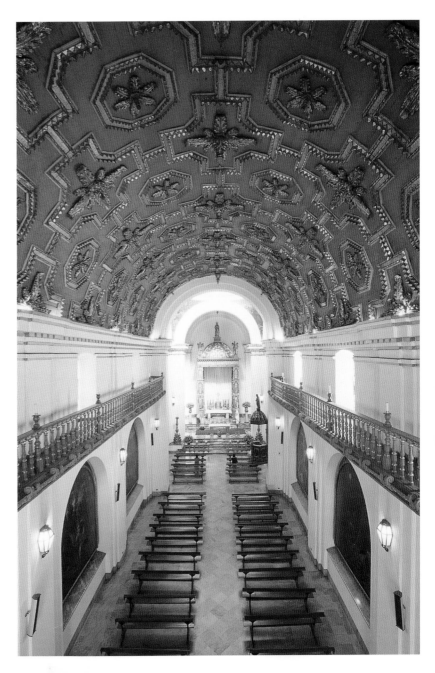

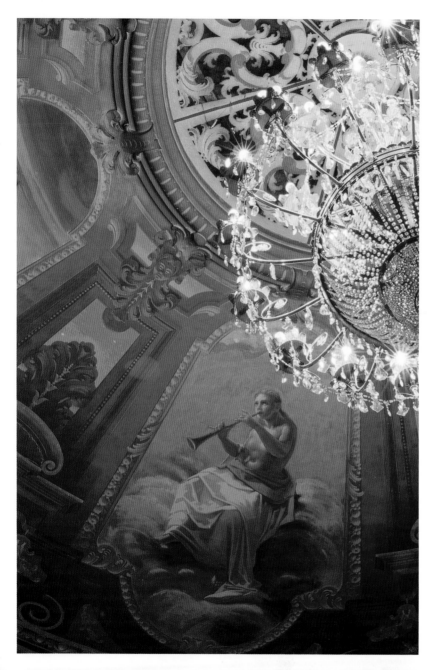

Cristóbal Colón Theater, Bogotá

Named after Columbus, it is one of Latin America's most beautiful 19th century theaters, built in the neo-classical style. It is located in the historic downtown sector of La Candelaria and its main hall opened in 1892. It is the setting for opera, drama and music. It was declared a National Monument in 1975.

Concert hall, Luis Ángel Arango Library, Bogotá

This is one of the country's most prestigious auditoriums, used for concerts and recitals. It was inaugurated in 1966 and won a National Architecture Prize for its extraordinary design and acoustics. Oval-shaped, it has a seating capacity of 367.

Museo del Oro (Gold Museum), Bogotá

It possesses the world's largest collection of pre-Hispanic goldwork, with nearly 35 000 pieces in gold or gold/copper alloy, as well as 30 000 ceramic, stone, shell, bone and textile ones, from the ancient Calima, Muisca, Nariño, Quimbaya, Sinú, Tairona and San Agustín cultures, among others.

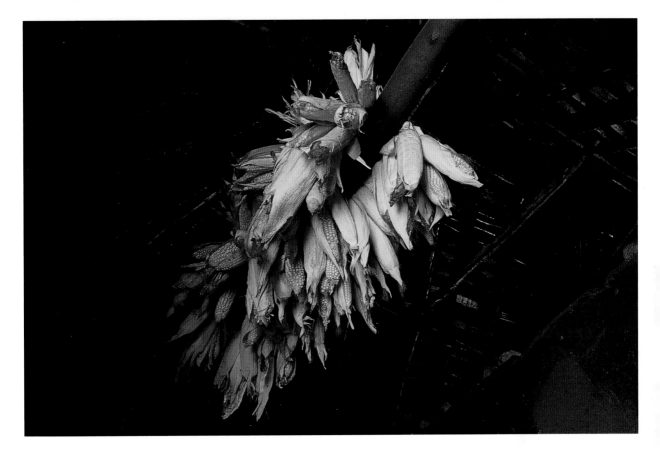

Dried corn, Sierra Nevada de Santa Marta

Known as the "sweet gold of Colombia" or the "seed of the Sun," maize was the most important foodstuff in the pre-Colombian epoch and continues to be the staple of the diet of the country's indigenous populations. Regarded as a fruit of the gods, it is closely linked to their mythology, religion and traditional medicine.

Museum of Antioquia, Medellín

Responsible for conserving and exhibiting the artistic heritage of the Department of Antioquia, it also houses works by other Colombian and foreign artists, historical pieces and examples of decorative arts. It is home of the Botero Donation: 108 paintings and 16 sculptures by Fernando Botero, in addition to 21 works from his prestigious art collection.

Procession of the "Nazarenes," Holy Week, Mompox

Around 1 500 men and boys take part in this annual procession, where they wear a Biblical-style costume of blue and white tunics and carry wooden sculptures, known as "pasos" (steps), on their shoulders which represent the 14 Stations of the Cross and honor the suffering of Jesus of Nazareth, from which they take their name.

Unquestionably linked to fire and blood, the color red is, by a general rule, associated with danger, war, energy, strength and determination. It is a color of intense emotions, which usually summons up the idea of ardent, unchecked passion, sexuality and eroticism or, in another context, courage and bravery. It also improves the metabolism of the body by increasing the rhythm of breathing and raising blood pressure. Highly visible, it is often used on signs, as a signal of warning or prohibition. Exultant and aggressive, the Spanish word, *rojo*, derives from the Latin *russus*. Red is seen in the floral decorations of El Peñon; the textiles, known as *molas*, made by the Cuna indigenous people; the costumes worn at the National Bambuco Beauty Queen contest; the articulated buses of Bogotá's Transmilenio rapid-transport system; macaws; the stream on El Tablazo mountain; the striking Tota lake of Boyacá and the saltworks of Manaure in the Guajira peninsula.

Pedestrian bridge, calle 100, La Castellana neighborhood, Bogotá

This traditional neighborhood is bounded by the Northern Highway, Avenida 30 and the calle 100. Because of its strategic location, it has kept march with the progress of the city.

Parque El Virrey, Bogotá

The Virrey (or Viceroy's) Park is the home of this iron sculpture, entitled Gran Cascada (Great Cascade, 1998) by the Popayán-born artist Edgar Negret. It is located at the intersection of the avenida 15 in the park, which is an example of the upgrading of public spaces which transformed the city at the end of the past century.

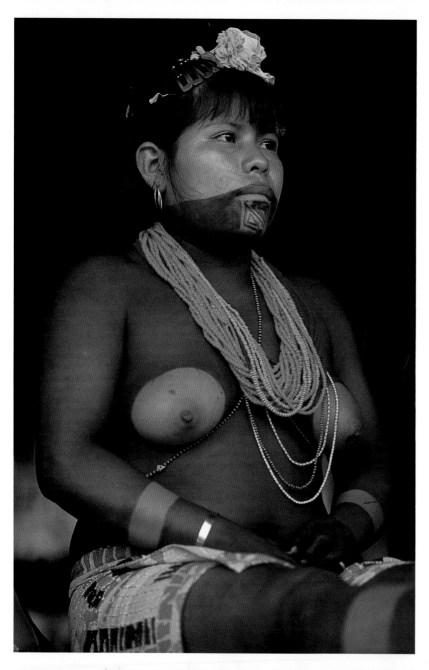

Embera indigenous girl, Jurubidi, Chocó

Among Colombia's indigenous population, the Embera are among the most widely spread, from the Chocó to the Putumayo. They conserve many of their traditional beliefs and a strong oral tradition. Their governing body is known as "Orewa," taken from the Spanish initials of the Chocó-based Regional Organization of the Embera-Waunana, which is divided, in turn, into local councils.

Weaving a hammock

The Wayuu indigenous women weave such hammocks, which are also called *chinchorros* in Spanish, on a vertical loom and, using a flat stick to tighten the weft, produce a heavy, rigid, compact fabric. Although some hammocks are of a single color (especially white), they usually combine a variety of them.

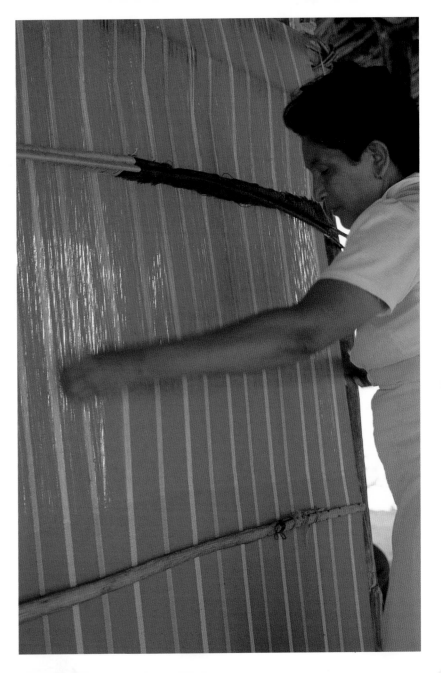

Holy Week, Mompox

In the days before Easter Week, members of the churches and religious brotherhoods devote themselves to preparing the statues and altars that will be used in the processions and ceremonies. Everything must be arranged in accordance with liturgical rules about colors and ornamentation. Such a task is called "dressing the saints."

Bullfight, Feria de Manizales

The architectural firm of Robledo and Borrero built this bullring, with a 12 000 spectators seating capacity. Known as the "Monumental," it was inaugurated on December 23, 1951 with a bullfight featuring the torero Antonio Bienvenida. The bullfights are held during the city's annual "Feria" (Fair), the fiestas held every January.

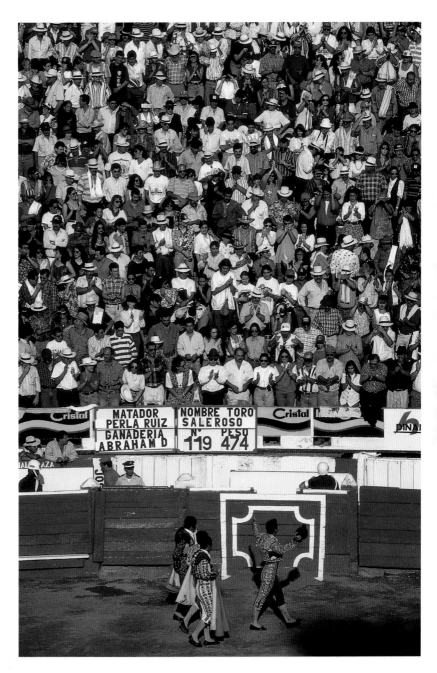

Carnival of the Devil, Riosucio, Caldas

This fiesta, which combines Spanish, indigenous and African cultural traditions, begins on the Day of the Holy Innocents and finishes on Epiphany (January 6th). Its high point is January 4th, when a statue of the devil on his throne goes on a triumphal march through the town, accompanied by people dressed in carnival gear, *chirimía* bands and groups reciting traditional legends.

Colombia Beauty Pageant, Cartagena

The fashion parade where the candidates wear fancy dress is one of the highlights of the Colombian Beauty Pageant. Colombian designers give full rein to their imagination with dazzling designs that use sequins, shiny fabrics, feathers, elaborate embroidery and enormous, colorful headgear. Hundreds of craftsmen spend months fabricating them.

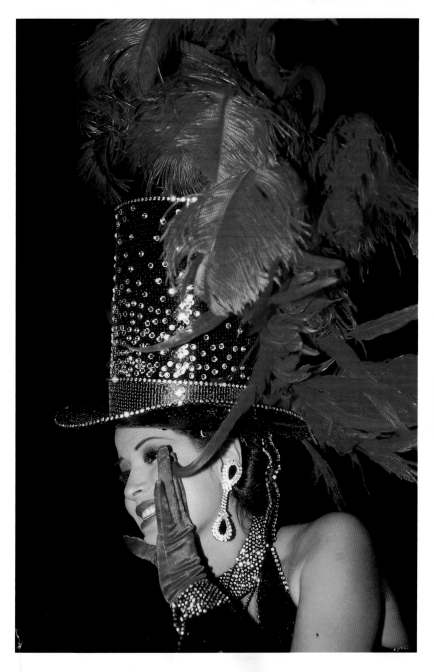

International Cockfighting Fair, Sincelejo, Department of Sucre

This event, which is no longer held, formed part of the traditional January festivities of Sucre, which include musical bands, accordion contests and the running of the bulls and are an emblem of regional culture. A national cockfighting fiesta takes place in Montería, however.

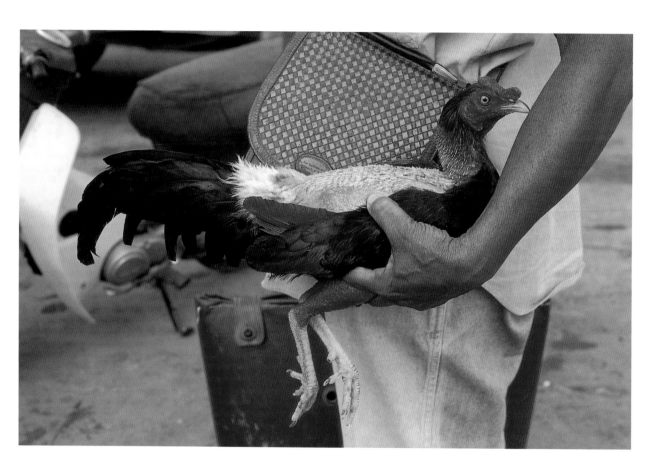

Quidbó, Chocó

Quibdó, standing at an altitude of 43 meters above sea level, is on the banks of the River Atrato. Founded in 1648 by the Franciscan friar Matías Abad, it became the capital of the Department of el Chocó in 1948. One of the rainiest places on the planet, its population is mainly Afro-Colombian and indigenous, including members of the Cuna, Embera and Waunana groups.

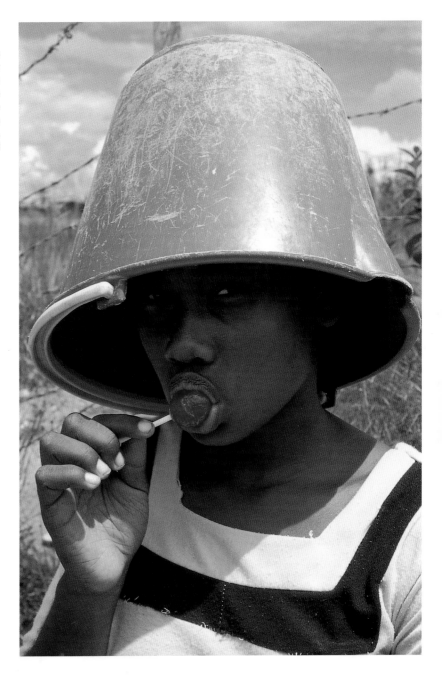

Portal of the Transmilenio rapid-transport system, Avenida 80, Bogotá

An innovative mass transport system, the Transmilenio has won international attention. Red articulated buses, carrying 160 passengers, run along lanes exclusively used by them and only stop at designated stations. They are supplemented by feeder buses, which transport people to outlying neighborhoods.

Brickworks, Sogamoso, Boyacá

In this city in Boyacá, bricks are made by family concerns using artisanal techniques. Known as *chircales*, these workshops form part of the landscape. The bricks are molded by hand, dried in open-air courtyards and baked in coal-fired ovens.

La Cocha Lake, El Encano, Department of Nariño

The town of El Encano, on the shores of the lake, is situated at a distance of 27 km from Pasto. At an altitude of 2 830 meters above sea level, it lies on the world's lowest paramo or high moor, which, due to the locality's geomorphic characteristics, has features similar to the higher Andean moorland. With an area of 8 hectares it has an average temperature of 11 °C.

"Chiva" bus, Riosucio

These old-fashioned buses, with barred, unglazed windows, colorful decorations and a space for passengers and baggage on the roof, are an emblem of Colombia. While they are still used in the countryside, rides on them have become a tourist attraction in the big cities. Their owners give them affectionate names, like "My beloved" and "Always true."

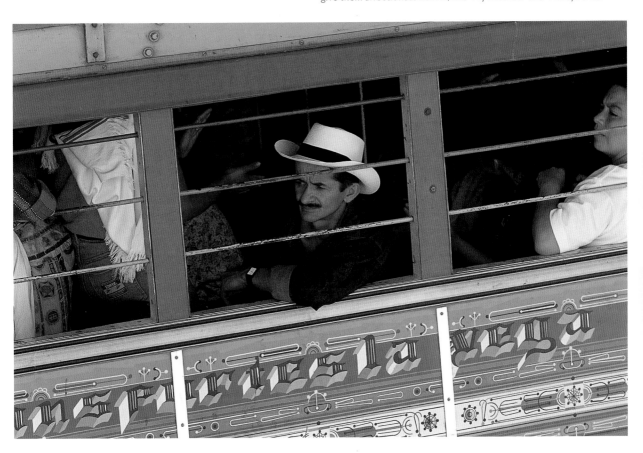

Children's Museum, Bogotá

The photo shows an outdoor passageway which links the modules devoted to genetics, Leonardo da Vinci and mechanical physics. The purpose of the Museum is to give children an interactive, experience-based tool for learning about the natural and exact sciences, art, computers, human life and the world which surrounds us.

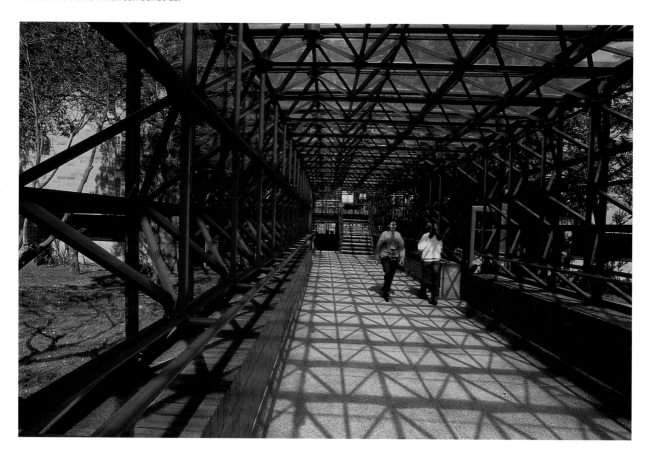

Pedestrian bridge, Ciudad Salitre, Bogotá

Ciudad Salitre (Salitre City) in the western part of Bogotá is a large-scale urban development which began in the 1960's. Carefully planned, it is one of the few parts of the city which successfully integrates residential, business, commercial, institutional and recreational activities.

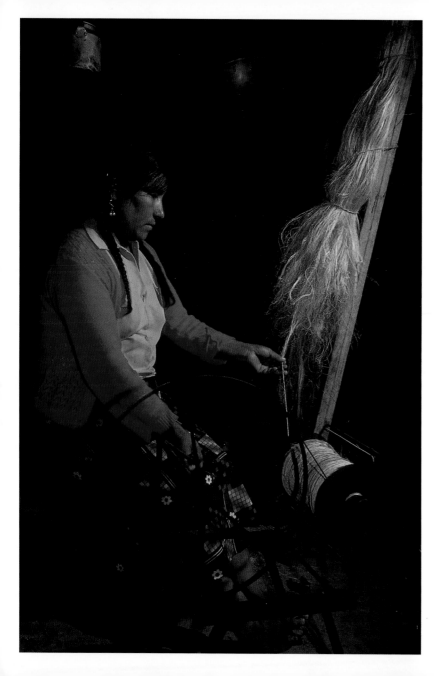

Woman spinning fique fiber, Sandoná, Nariño

Fique, a vegetal fiber, is used in a variety of traditional craftworks like garments, ropes, hammocks and sandals. Also known as *cabuya*, it is extracted from the spongy leaves of a xerophytic monocot whose scientific name is *Furcraea* sp., It produces a fine, strong, shiny, white fiber which is dried, spun or joined, twisted and sometimes dyed.

Shaman from the Inga indigenous group, Sibundoy, Nariño

During the ritual which surrounds the drinking of *yajé* (*ayahuasca*), the healer or "taita" uses a bunch of leaves, made from the branches of a small bamboo frequently found in the jungle, to cleanse the patients of bad energies. This leaf-fan is called the *wayra-sacha*, which means "leaves of the wind."

International Center, Bogotá

Located between Calles 26 and 32 and Carreras 7 and 14, this is one of the city's leading businesses, financial and cultural centers. Among other sites, it includes the San Diego church, the National Museum, the Bull Ring, the Hotel Tequendama, the Bancafé Tower and the Jiménez de Quesada Convention Center.

Bogotá Theater Festival

The inaugural parade of the biannual International Theater Festival starts at the Santamaría Bull Ring, proceeds along Carrera Séptima and finishes at the Plaza de Bolívar. It includes floats, bands, street performers, folklore ensembles, foreign theater companies and delegations from the carnivals of other cities.

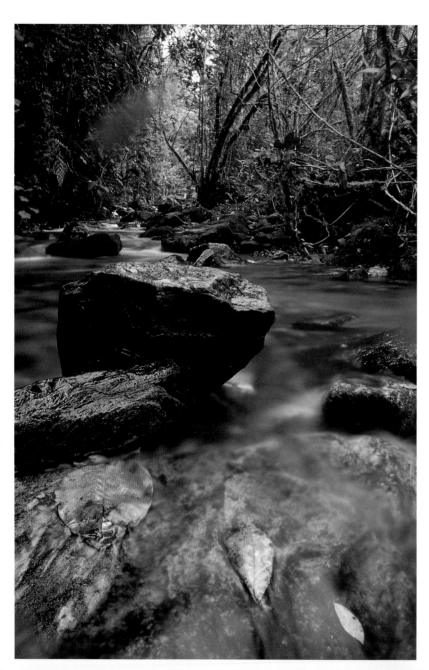

El Tablazo, Cundinamarca

The high savanna surrounding Bogotá reaches its western limit in the municipality of Subachoque, dominated by the imposing Tablazo mountain, which, from its 3 600 meters-high summit in the Andean moors, falls to an altitude of 2 450 near the town and plunges from there to the lowlands beyond the savanna. This creates a mosaic of thermal levels and unforgettable landscapes.

Caño Cristales, Sierra de la Macarena

This "stream of seven colors" is part of a river system, divided into two main branches, which flows down from the southern face of the Macarena mountain ridge in an eastward direction, forming a succession of rapids, falls up to 12 meters-high and pools sculpted out of the rocky bed. The aquatic plant *Macarenia Clavígera* gives the reddish tones to the stream.

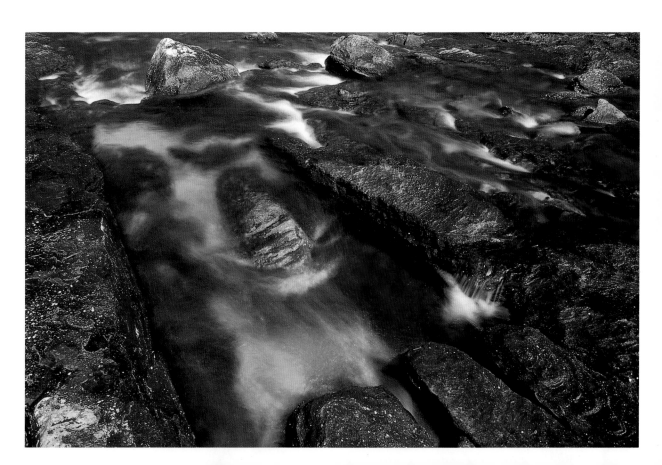

In our culture the color pink is generally associated with the female sex, delicacy, tenderness, blushing and even shyness. A delicate mixture of red and white, it is a color which transmits the values of ingenousness, kindness, calm and the absence of any evil. In Catholicism, it symbolizes happiness. The color used to illustrate the covers of sentimental romantic novels, pink was also the theme of a song by Aerosmith, which says that "Pink is like red, but not quite." Its Spanish name, *rosado*, derives from the Latin word *rosatus*. *In this country* pink is seen in the flora surrounding Guatavita lake, the cabo de la Vela, and the dress of the Wayuu indigenous nation of La Guajira. It is also found in the fauna of the southern town of Leticia, the sidewalks of San Bernardo del Viento, Los Nevados National Natural Park and the radiant species which live in the depths of the sea of the archipelago of San Andrés.

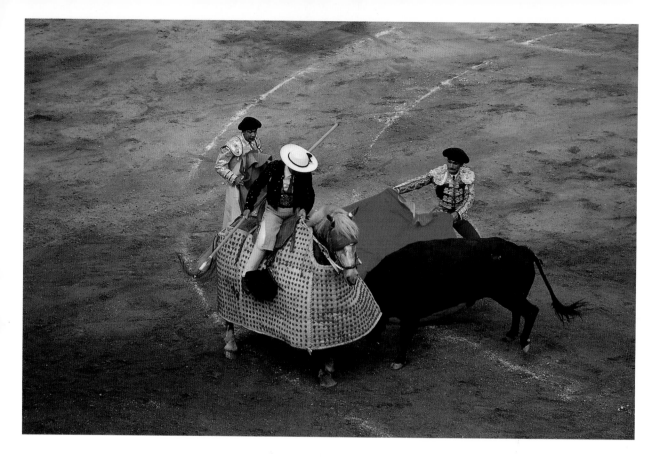

Bull Ring, Manizales, Department of Caldas

One of the most important bullfighting plazas in the country, it was built between 1948 and 1950 and inaugurated on the centennial of the founding of the city. It is a replica of the one in Cordova, Spain, with an arena whose diameter is 29 meters, and has space for 12 000 spectators.

Sibundoy, Department of Putumayo

Located 80 km west of Mocoa, the departmental capital, it has a predominantly indigenous population. It lies in a beautiful Andean valley, surrounded by mountains, with fertile soils and many streams. Its economy revolves around agriculture, cattle-rearing and handcrafts.

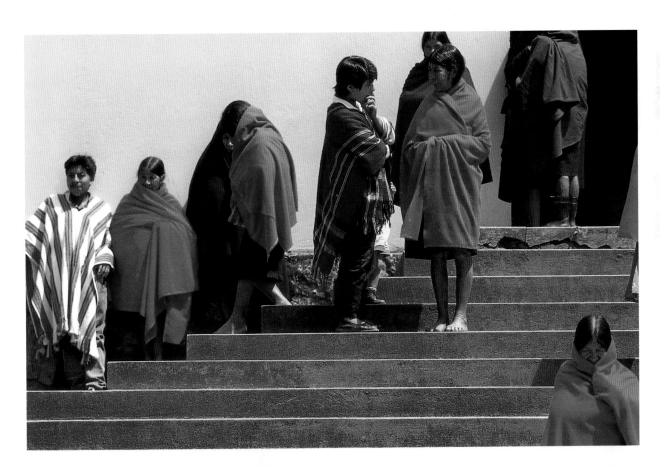

Coronation of the monarchs of the Children's Carnival, Barranquilla

Each January, in the run-up to the Barranquilla Carnival, the city choos-
es the Queen and King Momo of the Children's Festival. The event
follows the traditions of and features the same personages as the pre-
Lent Carnival for adults, one of the most authentic and best-known
in Latin America.

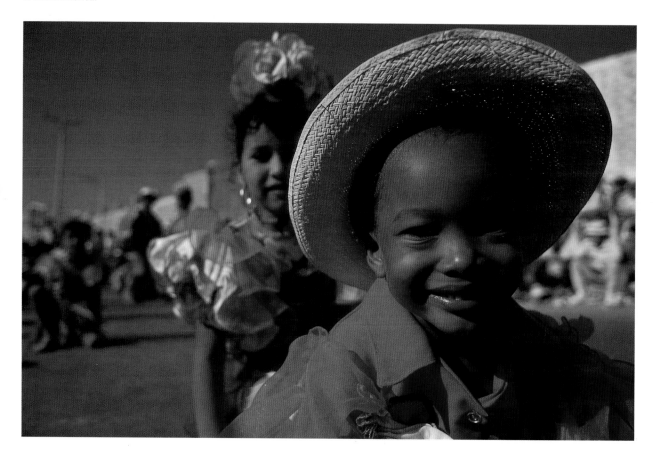

Rock in Spanish

The "Rock en español" movement began in the 1960's but did not take off until the 80's, when it received support from record companies and radio stations. Among the famous rock bands which emerged at that time were Compañía Ilimitada, Pasaporte, Kraken and La Pestilencia, among others.

Palm Sunday, Easter Week, Mompox

Carrying palm fronds, men, women and children take part in the Palm Sunday procession in this city in the Department of Bolívar, which marches from the Santa Bárbara to the Immaculate Conception church. Its centerpiece is a statue of Jesus seated on a small burro, accompanied by the twelve disciples.

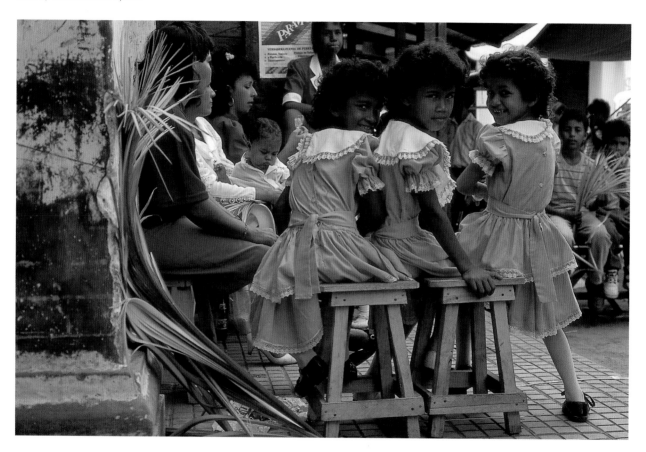

Riosucio Carnival, Department of Caldas

Held every two years in January, this carnival, whose symbol is the Devil, welcomes the New Year. The main event is a procession, featuring music, dancing and colorful costumes, which winds through the streets to the main square.

Buesaco, Nariño

Agriculture is the main activity of Buesaco, a municipality in the north-eastern part of the Department of Nariño, 81% of whose inhabitants live in the countryside. While it has an average temperature of 18º C, its different thermal levels allow for a wide variety of crops: coffee, beans, peas, wheat and barley, among others.

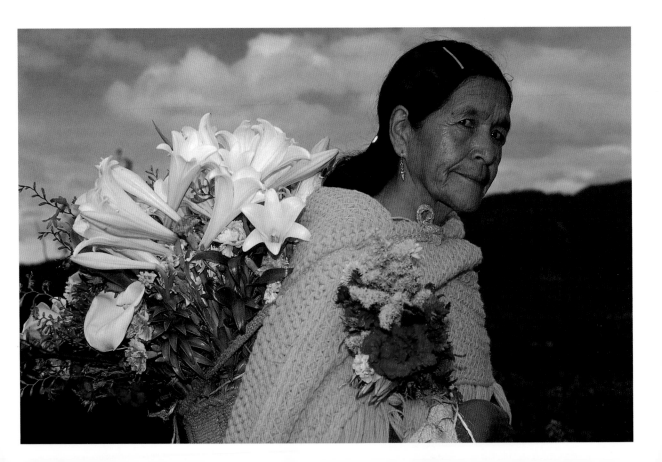

Country dwelling,
Cabo de la Vela, La Guajira

In La Guajira peninsula, facing the Caribbean, we find el Cabo (Cape) de la Vela, which is mainly inhabited by members of the Wayuu indigenous nation. It is a sacred site for them, since, according to their traditional beliefs, it is the place where their souls go to an eternal rest after they die. An isolated landscape where the desert meets the sea, its magic can be felt by anyone.

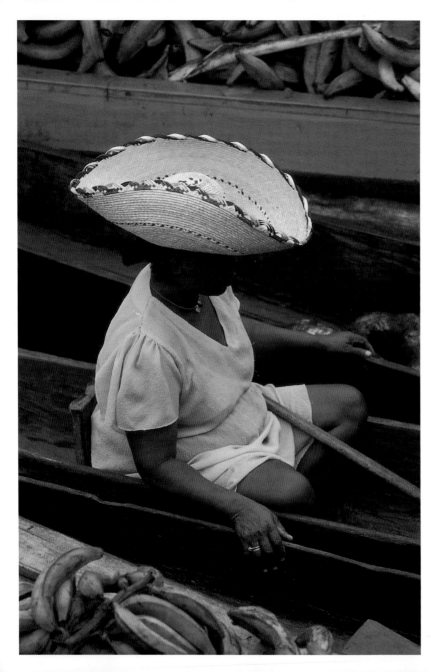

Guapi, Cauca

This town in the southwestern part of the Pacific region of Cauca takes its name from the river it overlooks, the río Guapi, and has a predominantly Afro-Colombian population. As the picture shows, life revolves around its waterways — the river, marshes and sea — which serve as its roads, shops and social centers.

Colombian Orchids

An orchid is the national flower of the Colombia, which harbors 10% of the world's orchids. They are a frequent sight throughout Colombia, where they grow from sea level to nearly 4 000 meters above sea level. They differ from other species in that the flower stays upside-down when it matures.

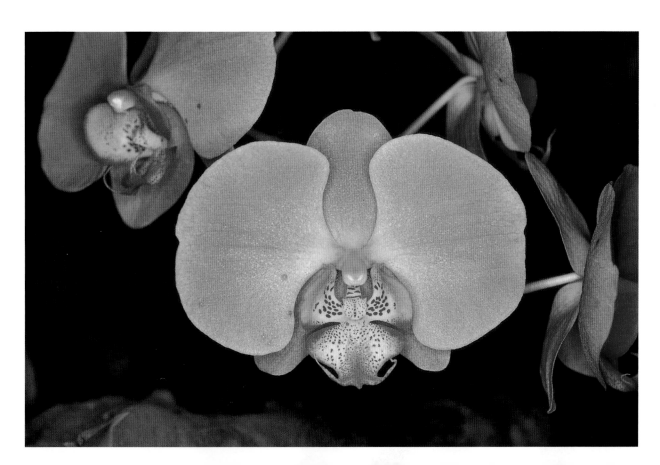

Cali, Department of Valle del Cauca

In this, the capital of Valle, street sellers and the informal economy have taken over the streets, avenues and public spaces, mainly in the city center. Churches and their surroundings are not the exception, since they are the site of sales of lottery tickets, religious images, scapularies and the like.

Leticia, Department of Amazonas

One of the main sources of income in this small, mostly indigenous city, which is the departmental capital, is tourism. It attracts thousands of visitors from Colombia, Europe and North America and is also a center of commerce with neighboring Peru and Brazil.

Saying Goodbye to the Old Year, Albán, Cundinamarca

The custom of burning or burying a doll that represents the Old Year is a widespread New Year's Eve custom in Colombia. Made of cast-offs, straw and other discarded materials, they often hold a bottle of liquor in their hands.

Salamina, Department of Caldas

This town in Caldas conserves a traditional architecture which employs *guadua*-bamboo, wood and ceramic roof tiles. Its houses have striking color contrasts, with carved details in the doors and window frames. For this reason it has been declared a National Monument and part of the country's Architectural Patrimony.

Tumaco, Nariño

The second-biggest city in the Department of Nariño and the country's most important Pacific coast port after Buenaventura, it is known as the "Pearl of the Pacific" by virtue of its beautiful seaside setting. Its inhabitants mostly work in commerce, agriculture, cattle-raising, fishing and timber extraction.

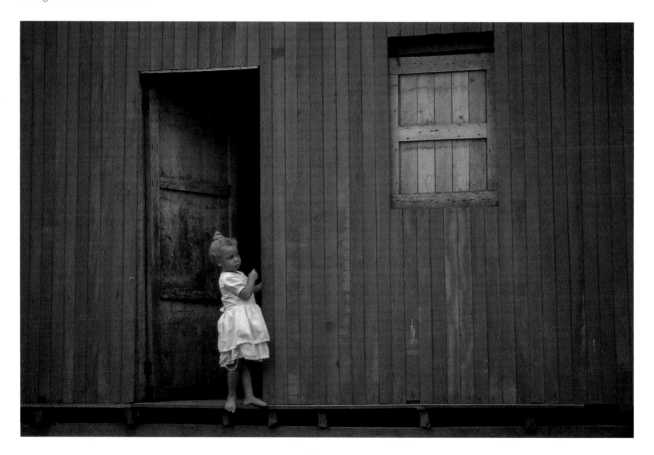

Roadside Altar, Puerto Salgar road

These altars are a common sight on Colombian highways and are generally the work of truck drivers who are devotees of the Virgin of el Carmen or the Christ Child of Prague, to whom they pray for safe journeys. They are usually decorated with old headlights, as a symbol of gratitude.

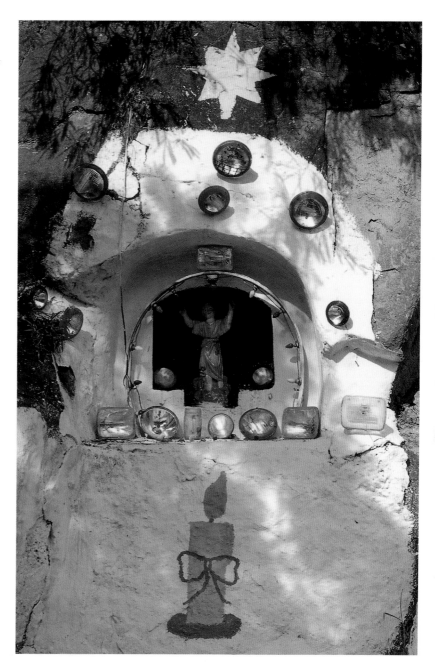

Los Flamencos Fauna and Flora Sanctuary, Upper Guajira

This magical refuge, named for the pink flamingos who visit it, lies in the hamlet of Camarones, Rio Hacha. Its delicate ecosystem includes innumerable varieties of birds, fishes, crustaceans and plants. The 7 687 hectares terrain is made up of marshes, lagoons and dry forests.

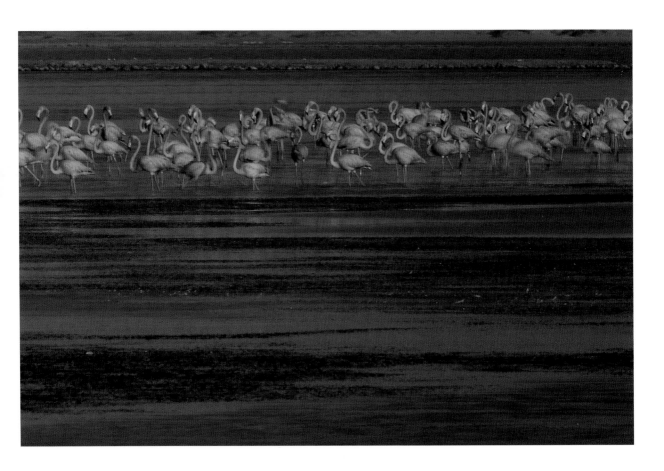

Parque del Renacimiento, Bogotá

Built in the 1990's on lands which formerly were part of the Central Cemetery on Calle 26, it is a place where people can relax from the downtown rush. Its pond, fountain, cultural center and lawns are an example of the recent urban renewal of this district.

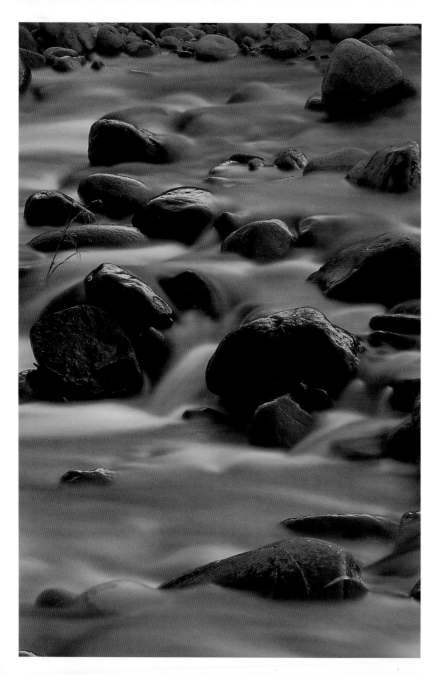

River Teusacá, San Rafael Reservoir

This river is born in El Verjón lake and flows in a northern direction for 75 km before debouching into the River Bogotá, crossing the town of La Calera. The reservoir in its basin supplies drinking water to Bogotá and regulates the flows of the Rivers Teusacá and Blanco.

Tairona Park, Department of Magdalena

This National Park has an area of 15 000 hectares, including a 3 000 hectares offshore zone. It lies 34 km north of Santa Marta, in the mountains of the Sierra Nevada. It has an incalculable cultural and natural importance, harboring, among other treasures, a great variety of marine species.

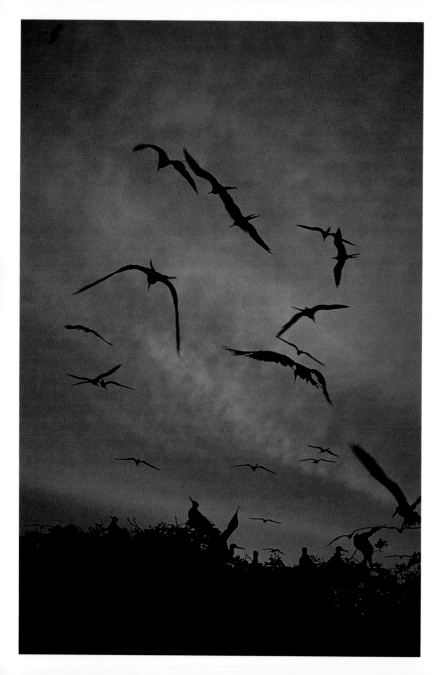

Frigate-birds, Caribbean sea

These rapacious marine birds glide over the tropical zones of the Atlantic and Pacific coasts. Despite their great size — their wing-span reaches 2 meters — they are very light, which affords them agility when they fly.

Tolemaida Military Base, Melgar, Tolima

The country's biggest military installation of its kind, Tolemaida is located in the town of Melgar, which lies in the valley of the River Sumapaz in the Department of Tolima. A major weekend resort for people from Bogotá, Melgar is known as the "city of the swimming pools," of which it has more than 5 000.

Cold by nature and used since antiquity, it is highly valued because it is costly to obtain. In the ancient world it symbolized sovereignty and the grandeur of the monarchs: an idea which the Roman emperors borrowed from the Orient and was taken up by kings and emperors in the Middle Ages, for whom it was a symbol of authority. For these reasons, it has long been a heraldic emblem of greatness, justice and wisdom. It also represents devotion to the truth and inventiveness, as well as respect, dignity and self-esteem. It is associated with a thoughtful mind, ruled by logic and reason, and advanced age and inner balance. Purple may be seen in the dawns of the Andean mountains, the gulf of Utría, the costumes of the flower-carriers' parades in Medellín known as *silleteros*, and certain houses in Antioquia, the jungle bordering the River Caquetá and the landscape which surrounds the River Guavio.

Guatavita Lake

Lying at a distance of 80 km from Bogotá, this place was the navel of the world for the ancient Chibchas and the lake a gateway to the realm of the gods. It was here that the legend of El Dorado arose. In the Muisca language, Guatavita meant the "tip of the cordillera" and was associated with spiritual retreats, gold offerings and the adoration of the gods of water.

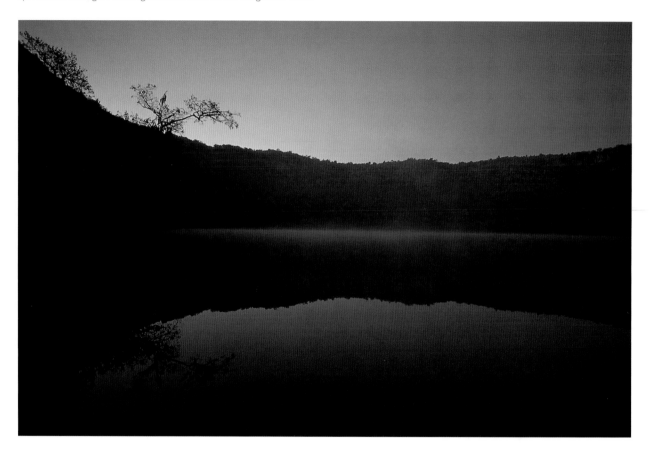

The supra-paramo, nevado del Ruiz

The terms refers to the strip of land, between 4 300 and 4 700 meters above sea level, just below the snowline but above the high Andean moor land known as paramo. The terrain is mostly sandbanks and rocks with a highly-specialized vegetation of lichens. It is sometimes called a lunar valley.

Construction boom, Cartagena

In the past decade or so Cartagena has gone through an amazing architectural and urban renewal boom. In the historic walled city, old public buildings and private homes have been restored, while a host of tall apartment buildings, hotels and office blocks have been built in the outlying districts of Manga, Getsemaní, Laguito and Bocagrande.

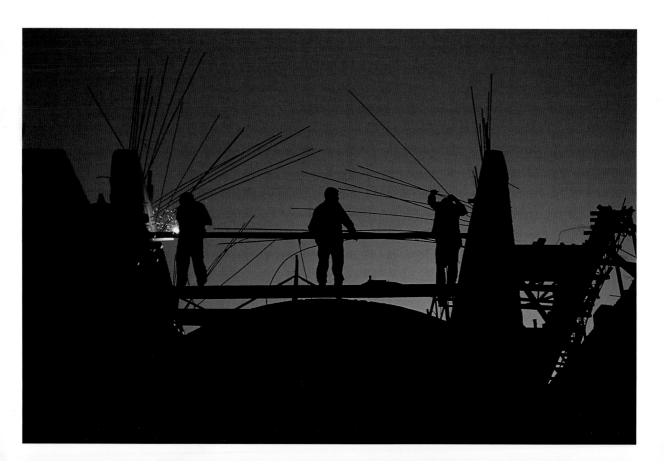

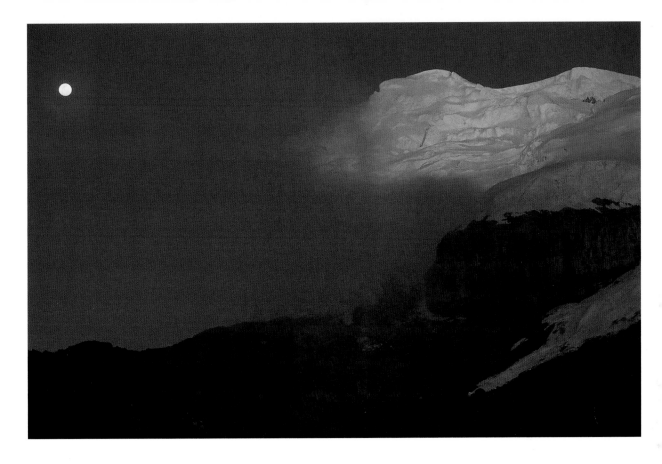

El Huila snow-capped volcano, Central Cordillera

This is the highest mountain of the Central Cordillera. Its snowfields have crevasses from which sulfurous gases issue and they are surrounded by crystallized sulfur. It has three crests: the northern one, at 5 365 meters above sea level, the central one, at 5 240 meters and the southern one, at 5 610 meters. It is also known as the Páramo de Paez.

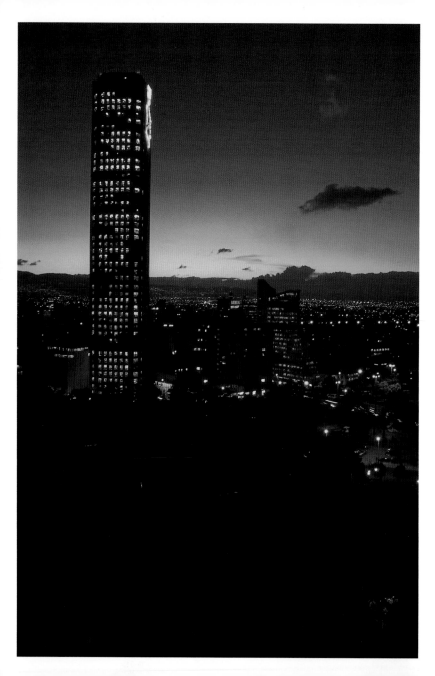

Colpatria Tower

This 50-storey, 196 meters-high office block is the country's tallest building. It was built in 1978 by the firm of Pizano, Pradilla and Caro. Its outstanding feature is the lighting system of 36 xenon lamps which bathe its walls in a striking display of constantly-changing colors.

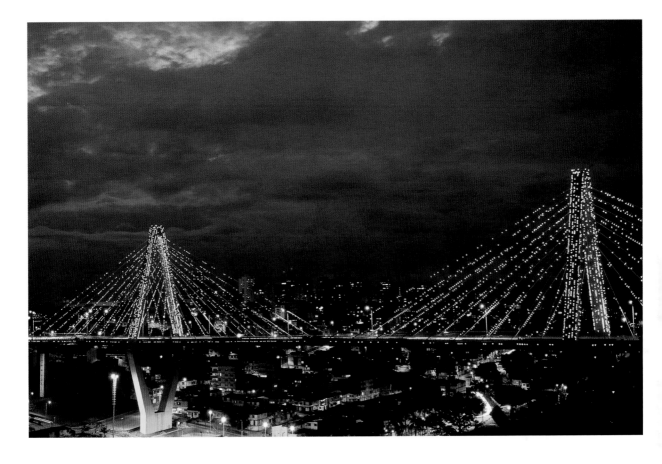

César Gaviria Trujillo Viaduct, Pereira

Sponsored by Invias, the government road-building agency and built by a Brazilian-German consortium, the Pereira viaduct was opened on November 15, 1997. It is a suspension bridge over the River Otún which links Pereira to Dosquebradas and is an emblem of the city. Its central section is 211 meters-long.

Palm trees, río Caquetá, Amazonas

After Brazil, Colombia has the largest number of palm species in the world. According to one scientist, of the 1200 known species of palms Colombia possesses nearly 300, spread over 50 genera. With the exception of snowfields, they are found in all climates, although they prefer warm, humid ones.

Sunset over the prairies of Casanare

The Department of Casanare is bounded by the Rivers Casanare and Meta and the foothills of the Eastern Cordillera, the source of the most of the rivers which run through its flat or slightly undulated terrain. Among them there are the Rivers Upía, Cusiana, Cravo sur, Ariporo, Guachiría and Pauto.

Popayán, Cauca

Known as the "White City of Colombia," it was founded by the conquistador Sebastián de Belalcázar on January 13, 1537. From colonial times and throughout the 19th century, it was a major political, economic and social center.

Templo de La Ermita, Popayán, Cauca

This church was built at the time of the founding of the city. It survived the 1564 earthquake, replacing the city's cathedral until 1612. It likewise stood up to the earthquakes of 1736 and 1826 and even the devastating one in 1983, after which it nevertheless had to be restored.

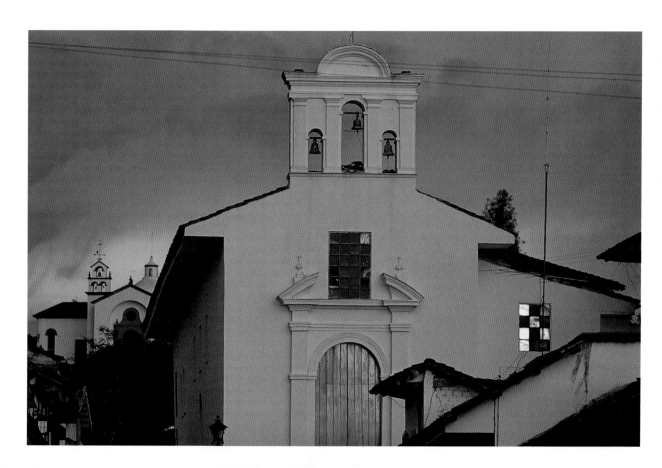

Sandoná, Nariño

One of the major economic activities of the region where it lies is the manufacture of hats and accessories from the fiber of the Iraca palm (*Carludovica palmatta*), which is also known as *paja toquilla*. Women usually weave these crafts goods, which are famous all over Colombia and also exported.

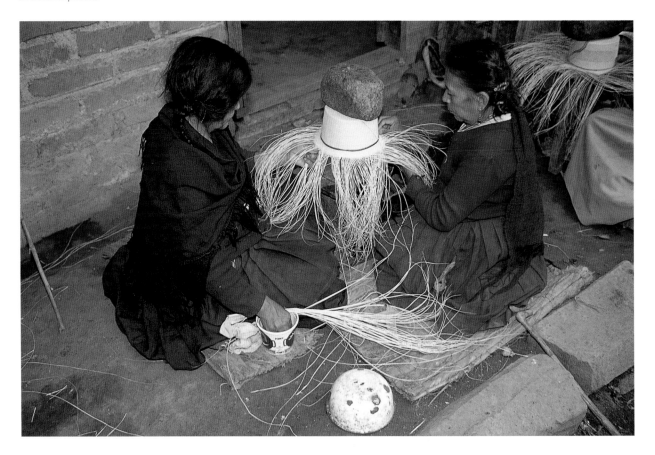

Easter Week Procession, Pamplona

The whole ritual which surrounds the Holy Week procession speaks of a sumptuous ceremonial: the statuary with its dress embroidered in gold, silver and lace and the rich costumes of those who carry the figures, which hide their faces but indicate their rank within the religious brotherhood.

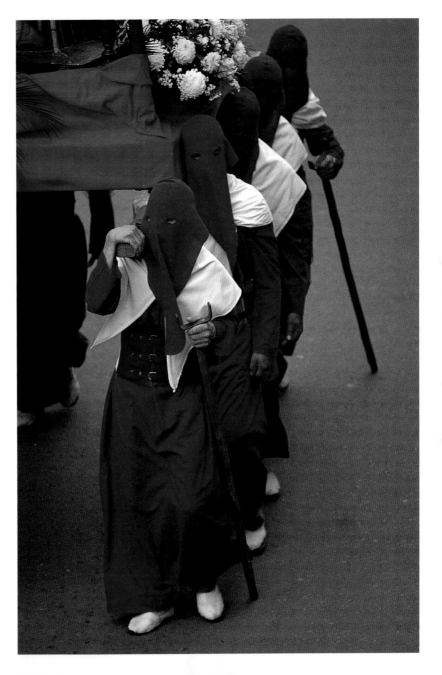

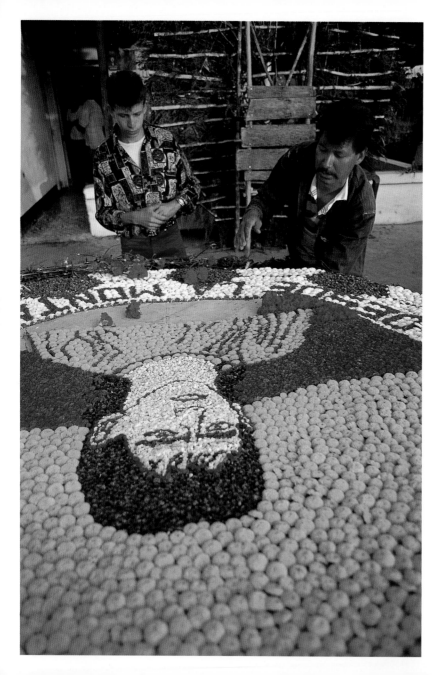

Flowers Fair, Medellín

These fiestas celebrating the region's flower-growing industry feature concerts, dances and tango displays, which take place in a variety of sites, like the Parque Lleras and the Zona Rosa. The route of the main parade varies from year to year, but it usually runs along major avenues like the 70th, San Juan and Oriental.

Hammocks made by the Wayuu indigenous group, La Guajira

The hammock or *chinchorro* is a basic article of this semi-nomadic culture, a place where they sleep, eat, relax and receive visitors. It is also used as a shroud. It is made up of the central piece, the braided ends, the flatly-woven cords and the border of crochet-work tassels.

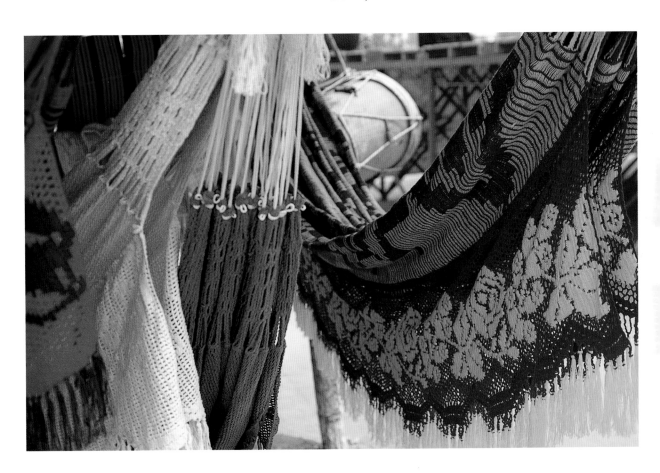

Flowers of the sietecueros tree, Rionegro, Antioquia

The Spanish name, "seven skins (or hides)" refers to the many layers of reddish-orange bark, which flake off from the tree. Its colorful flowers make it an attractive adornment of humid forests. The young flowers have a magenta tone which later changes to blueish violet. It is a native of the Andes, ranging from Venezuela to Peru.

Quinta de Bolívar, Bogotá

Originally known as Quinta Portocarrero, was given to Simón Bolívar in 1820 by Tiberio Echavarría. It was the place where the Liberator entertained the great love of his life, Manuelita Saenz. When he exiled himself from Colombia, he bequeathed it to José Ignacio París. It was turned into a Museum in 1922 and displays furniture and objects used by Bolívar.

Colombian flowers

Colombians' passion for flowers may be seen in places which range from the houses of the peasant-farmers to the large-scale flower-growing industry in cities like Bogotá. Flowers are the country's third largest export item, only surpassed by oil and coffee, and they are also a major source of employment.

Cymbidium

This orchid comes from tropical Asia, but it has acclimatized itself to warm, humid regions of Colombia and some species even prosper in higher, colder zones. They are the most widely-grown orchids in the world, since they are easy to cultivate and produce hybrids of every color.

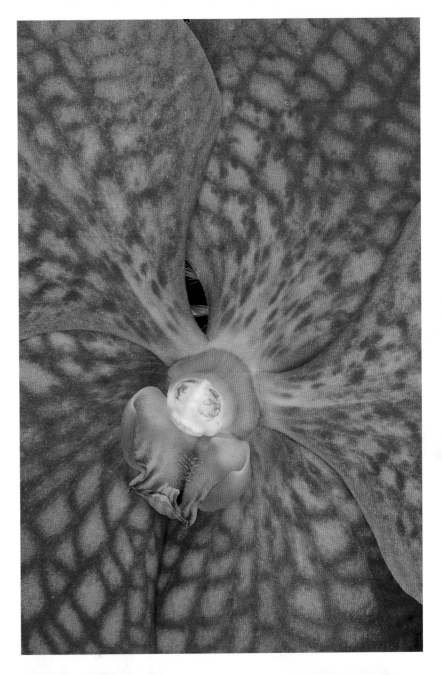

A Park in Bogotá

The city's District Park System includes more than a thousand parks, ranging from the large metropolitan to the small neighbourhood one. They represent an effort to conserve green spaces for public use where people can commune with nature, relax or play sports.

Wayuu Festival, Uribia, La Guajira

The raw material most widely employed in the crafts work of the Guajira indigenous people is cotton thread, which is woven into a variety of articles, like brightly-colored *mochilas* (shoulder bags), the *mantas* (shawls) and *kannas* (sashes) worn by their women, *waireñas* (sandals) and hammocks. They also produce pottery and bracelets and necklaces from a variety of materials.

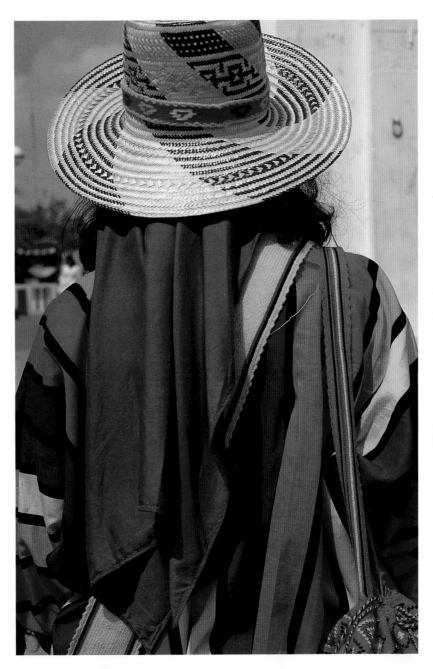

Flowers Fair, Medellín

Celebrations surrounding this fair include the international flower queen beauty contest; the parade of *silleteros* (men who carry heavy flower arrangements on their backs); an antiques fair; a horse fair; a musical band festival; exhibits of orchids, birds and flowers; "troubadours", and a caravan of the old-fashioned buses known as *chivas*.

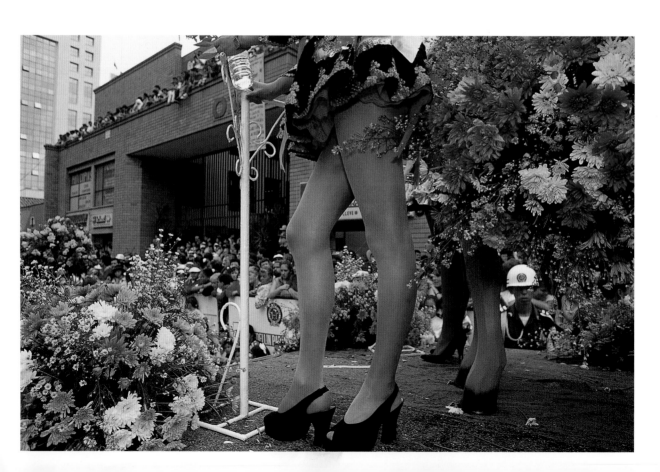

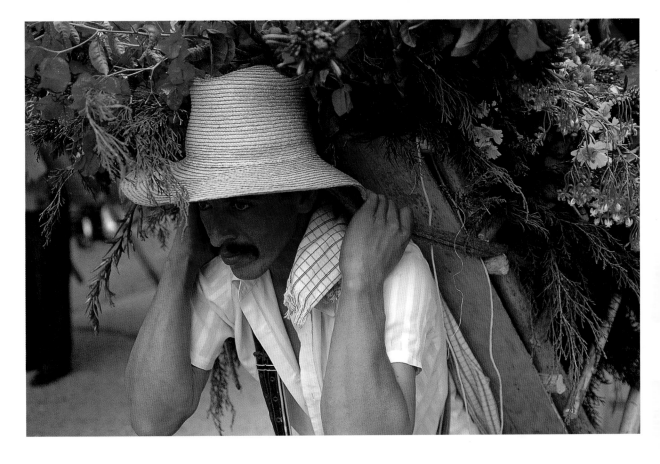

Flowers Fair, Medellín

Medellín held its first Flowers Fair on May 1, 1957, on the initiative of Arturo Uribe Arango. It included a flower exhibition in the atrium of the cathedral and a discreet parade of the flower-growers of Santa Helena. In the half-century since then it has turned into one of the country's biggest festivals.

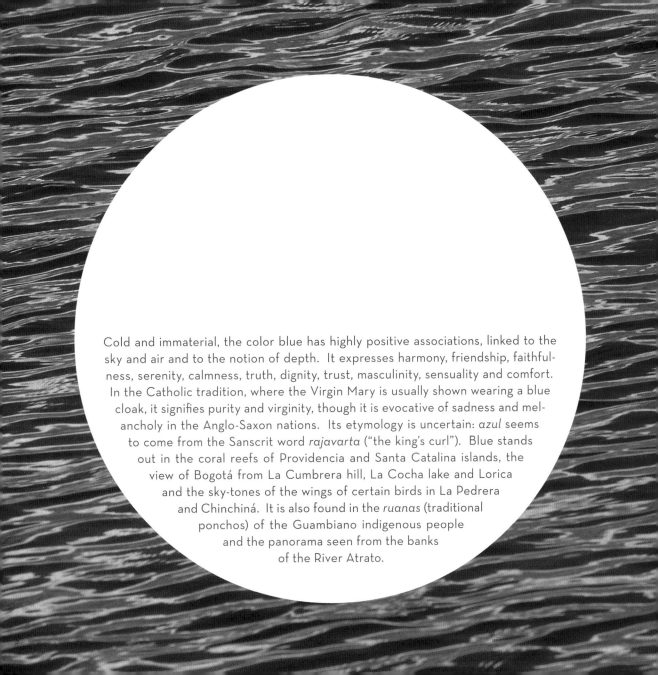

Cold and immaterial, the color blue has highly positive associations, linked to the sky and air and to the notion of depth. It expresses harmony, friendship, faithfulness, serenity, calmness, truth, dignity, trust, masculinity, sensuality and comfort. In the Catholic tradition, where the Virgin Mary is usually shown wearing a blue cloak, it signifies purity and virginity, though it is evocative of sadness and melancholy in the Anglo-Saxon nations. Its etymology is uncertain: *azul* seems to come from the Sanscrit word *rajavarta* ("the king's curl"). Blue stands out in the coral reefs of Providencia and Santa Catalina islands, the view of Bogotá from La Cumbrera hill, La Cocha lake and Lorica and the sky-tones of the wings of certain birds in La Pedrera and Chinchiná. It is also found in the *ruanas* (traditional ponchos) of the Guambiano indigenous people and the panorama seen from the banks of the River Atrato.

El Islote, Islands of San Bernardo

The Islote or Islet is a manmade island, thought to be the most densely-populated place on earth. It has an area of 5 600 square meters and around 1 100 inhabitants, which is the equivalent of 194 000 inhabitants per square kilometer. A large proportion of them are children, each family having an average of five of them.

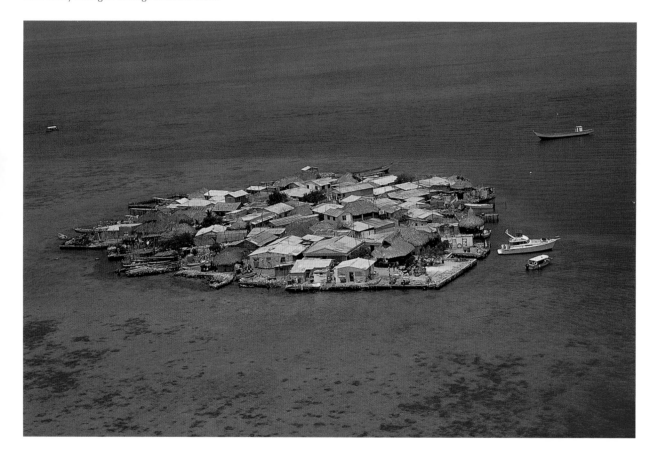

Cayo de Serrana, Archipelago of San Andrés and Providencia

The keys of Roncador, Serrana, Serranilla, Rosalinda, Bajo Nuevo and Quitasueño are part of the Colombian archipelago of San Andrés and Providencia in the Caribbean. They are formed from the highest peaks of a long coral reef, which lies a little way below the surface of the sea.

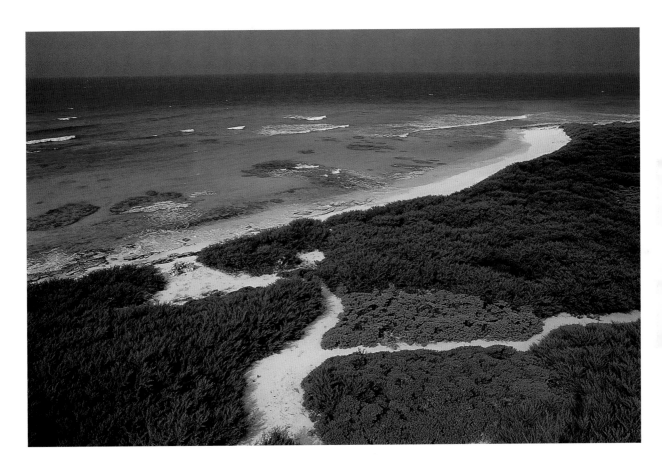

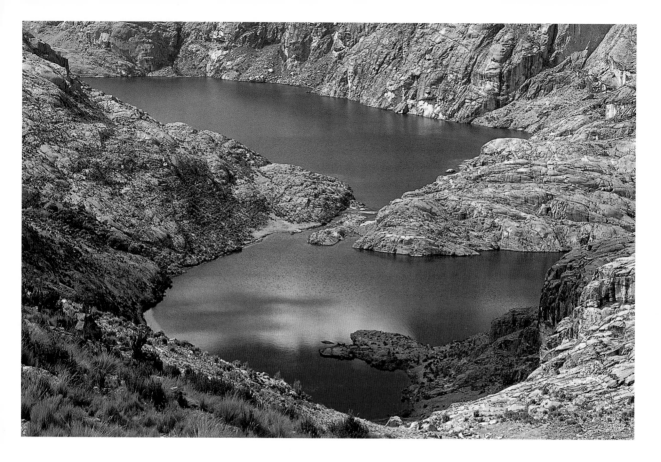

Glacier lakes, Sierra Nevada de Santa Marta, Magdalena

These shallow lakes are formed when waters from ice thaws are deposited in circular hollows in the glaciers, at an altitude of more than 3 000 meters above sea level. They contain a number of aquatic plants, and scrubs and *frailejón* plants grow on their shores.

Island of Providencia

Lying 480 km off the coast of Colombia, the Caribbean islands of Providencia, Santa Catalina and San Andrés form part of an archipelago. Their crystal-clear waters, beautiful scenery and well-conserved marine life make them a major tourist attraction.

Ciénaga Grande de Santa Marta

This complex of lakes and marshes, with an area of 4 280 km, is found in northern Colombia, in the Department of the Magdalena and is the biggest in the country and one of the most important in the world. Some of its inhabitants live on stilted houses in its waters.

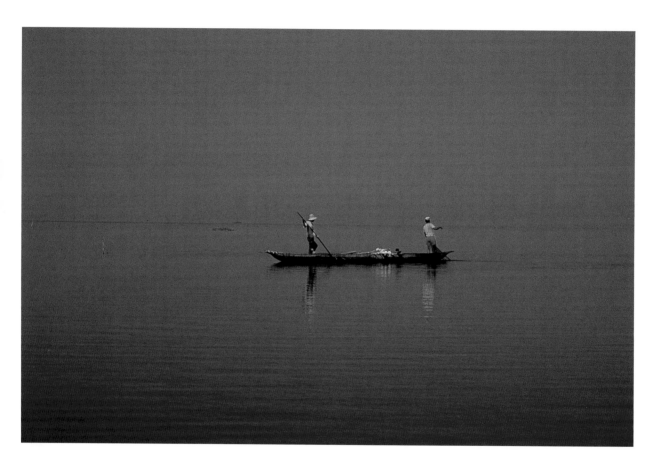

Flandes, Tolima

Located near the towns of Girardot and Ricaurte, Flandes is one of the major tourist towns in the upper basin of the River Magdalena, with a wide range of hotels, condominiums, recreational activities and restaurants.

Street theater, Ibero-American Theater Festival, Bogotá

Held every two years, this festival attracts nearly 3 million spectators from all over Colombia and foreign countries as well. It presents some 600 works in conventional theaters, along with 200 street companies devoted to theater, dance, circus, performance, pantomime and concerts.

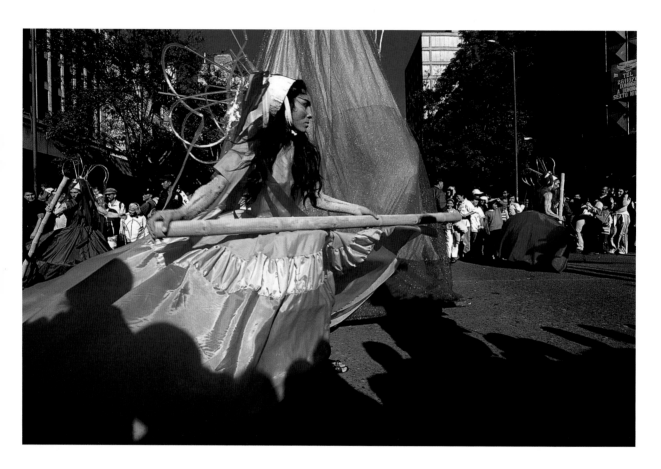

Members of the Paez indigenous group

One of the main Native American groups of the country, representing about 17% of the total indigenous population, the Paeces mostly live in the Department of Cauca. They are an agricultural people and cultivate a variety of crops on their smallholdings.

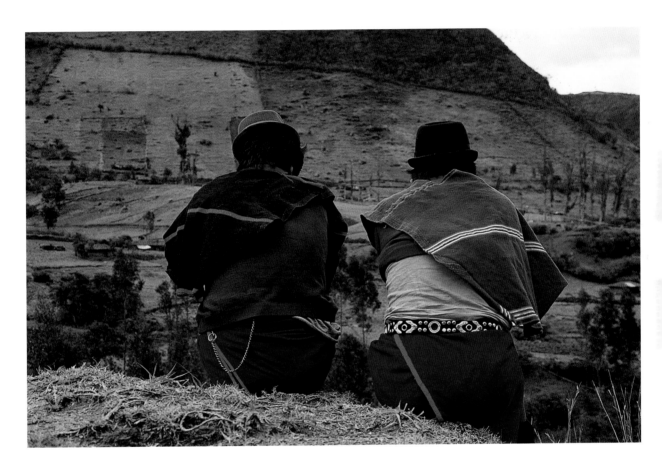

Barichara, Santander

Founded by Francisco Pradilla y Ayerbe in 1705, this is one of the most beautiful and best-conserved colonial towns in Colombia, characterized by its stone-paved streets, wooden window grilles, ornate doorways and white façades with a contrasting strip of blue or green.

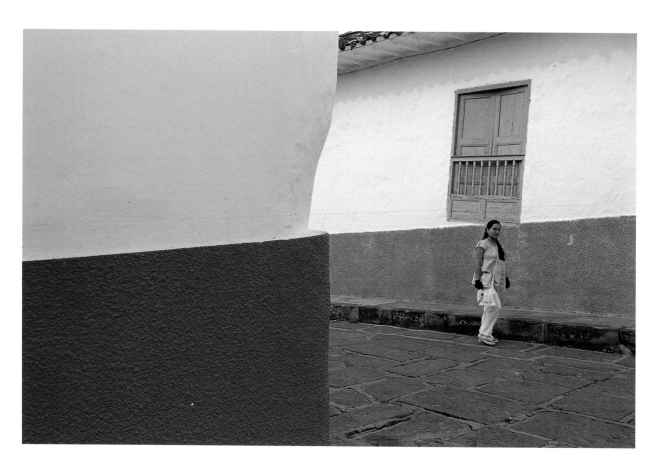

Barichara, Santander

Located at a distance of 118 km from Bucaramanga, Barichara is a charming place full of historical associations. Its mid-18th century center was declared a National Monument in 1978. It is known for the graceful colors and stonework of its colonial houses.

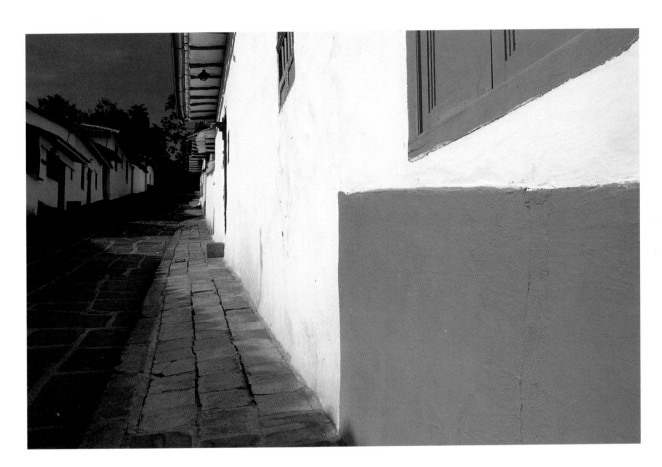

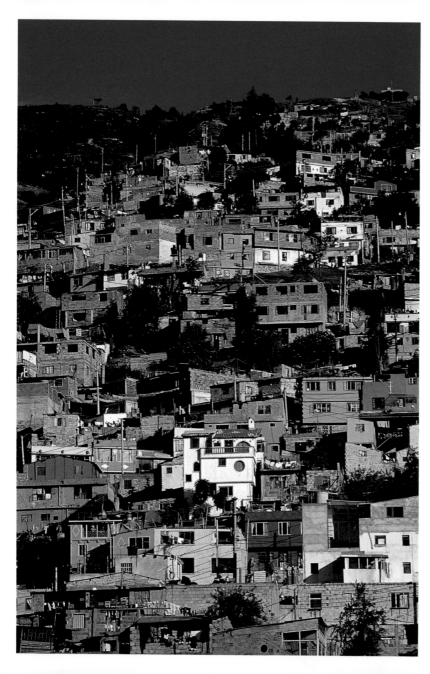

Life on the Andean foothills of Bogotá

Of the more than 1 000 neighborhoods that exist in Bogotá, some of the most picturesque are the ones built on the slopes of the Andean ridges (known as *cerros*), which overlook the city, especially in the south and southeast. Many of them begin as favela-type settlements put up by poor, displaced people.

El Campín Stadium, Bogotá

Named after Nemesio Camacho, the father of the man who donated the property to the city, it was inaugurated in 1938 on the occasion of the Bolivarian Games and it is the home ground of the Independiente Santa Fe and Club Los Millionarios soccer teams. It is used for a variety of Colombian and international sporting events.

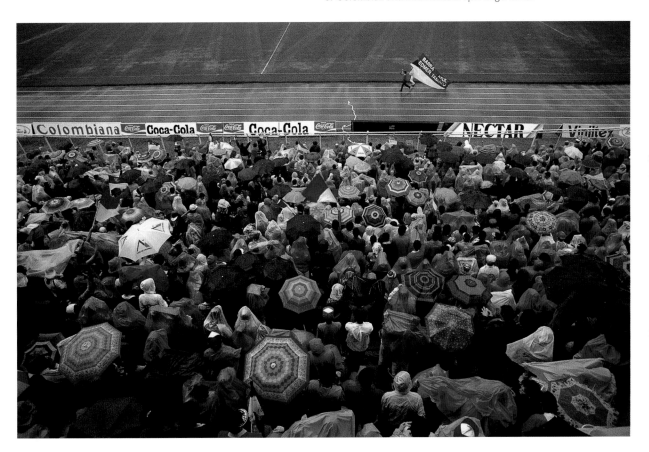

Roadside food vendors, Pereira, Risaralda

The selling of food along highways is one of the most characteristic sights of Colombia. In many places, local peasant-farmers offer the fruits and vegetables they grow themselves. Other products include homemade cheeses, breads and beverages.

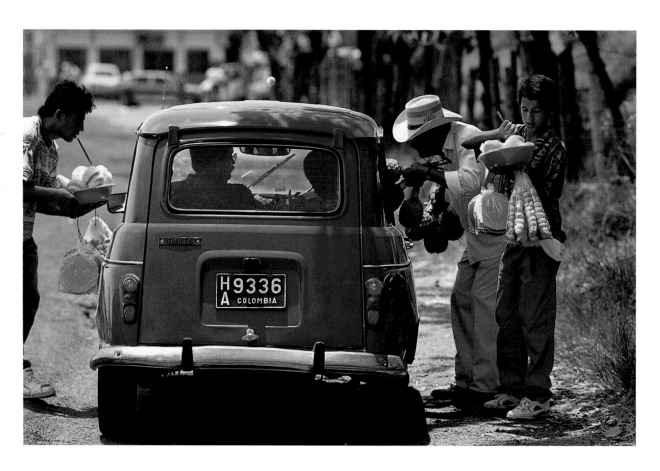

Ráquira, Boyacá

One of the most beautiful villages in the Department of Boyacá, it is known for its colorful houses, traditional customs and crafts work, such as woolen textiles, basketry and above all, a wide range of pottery products.

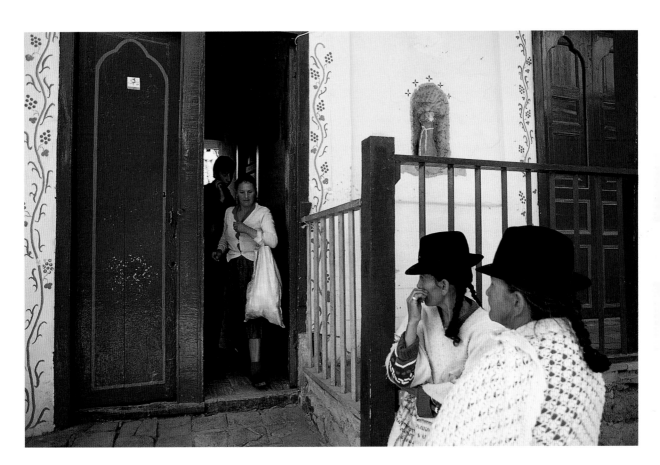

Palacio Liévano, Bogotá

The Liévano "Palace" lies on the western side of the Plaza de Bolívar and is the seat of the Bogotá Mayor's Office. Commissioned by Indalecio Liévano and designed by the French architect Gaston Lelarge, it was built in the early 20th century on the site of the Galerías Arrubla, destroyed by a fire in 1900.

Palacio Nacional, Medellín, Antioquia

One of the emblems of the city, it is the work of the Belgian architect Agustín Goovaerts and was built between 1925 and 1933 in a mixture of the Romanesque and Neo-Gothic styles. It is known for the elaborate, inter-laced grille-work in wrought iron which adorns its doors, railings and windows.

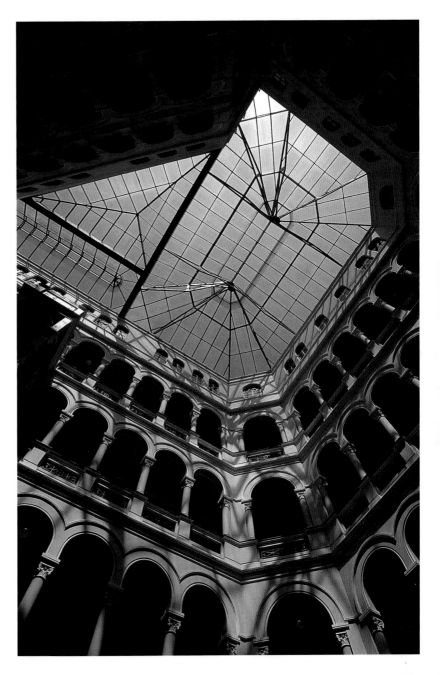

Whale Shark

The whale shark is the world's largest fish. It lives in warm tropical and subtropical waters, including the seas of Colombia. The Fauna and Flora Sanctuary on the Colombian island of Malpelo is one of the best places to watch these sharks.

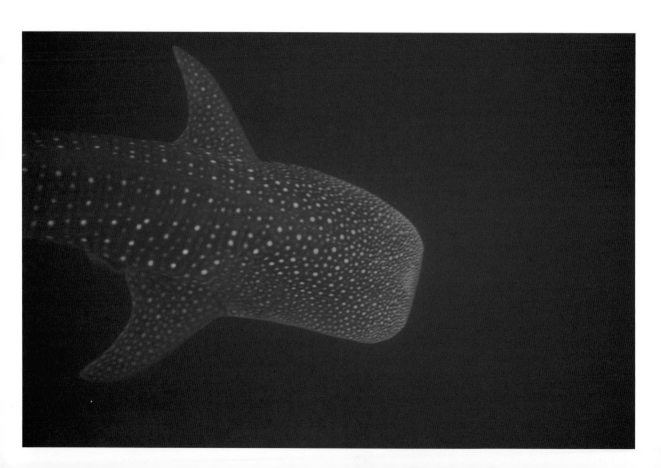

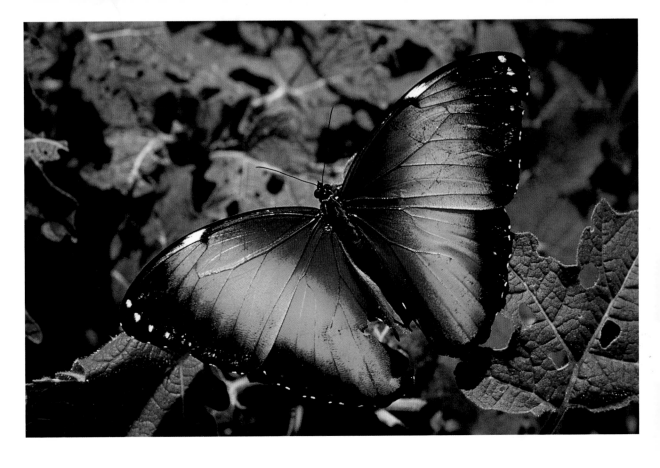

Morpho Butterfly

Known for the striking blue color on the dorsal part of its wings, the habitat of this butterfly ranges from Mexico through Central America to South America, from sea level to 1 800 meters above sea level. A forest-dweller, it is frequently seen in coffee groves.

Caño Casiquiare, Meta

This river, which starts in Venezuela, runs into the basins of the Amazon and Orinoco in Colombia, where, in a rare natural phenomenon, it diverts a third of the volume of the Orinoco towards the River Guainía (or Negro) through a natural channel.

Avenida 80, Bogotá

Known as the Medellín highway, it is one of the major roads in Bogotá, running east-west from Los Héroes monument to the River Bogotá. Since the year 2000, it has been one of the routes of the Transmilenio urban-transport system, with 14 stations.

Southern prospect of the Andean ridges of Bogotá

These mountains, whose altitudes range from 2 800 to 3 600 meters above sea level, are found in the eastern part of the savanna region and are an extension of the Sumapaz Massif. They are made up of peaks, ridges, passes and high moors. Of the ridges, which overlook the city, el Cable, Monserrate and Guadalupe are among the best-known.

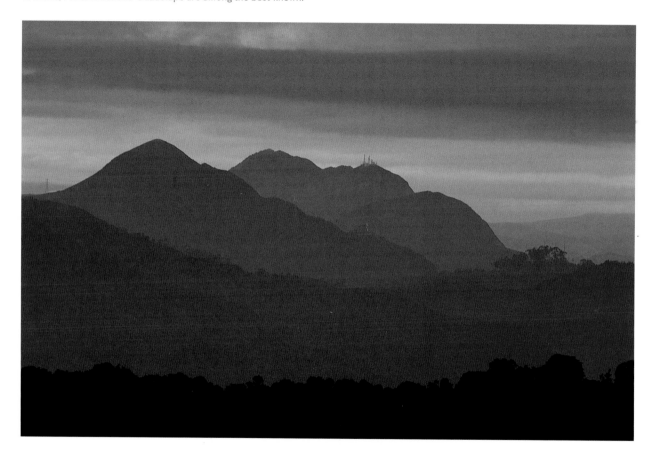

Sanquianga National Natural Park, Nariño

Located along the Pacific coast of the Department of Nariño, on a mostly flat terrain of 80 000 hectares, this park, opened in 1977, is made up of flat shore land, delta islands in the bays of Tapaje, Amarales and Sanquianga, and the Bocanas de Guascama and Barrera.

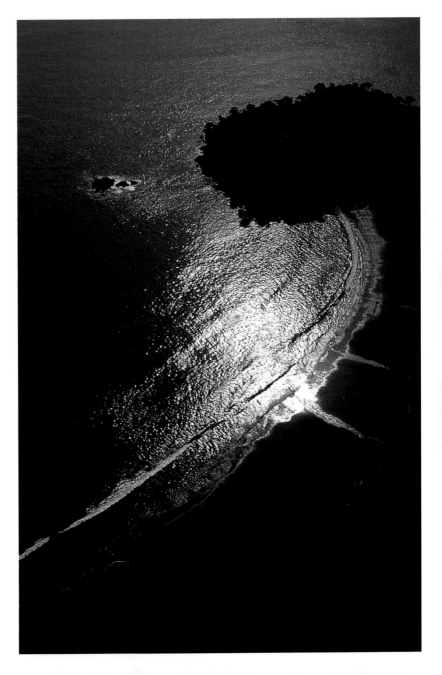

The color of hope, green is also frequently associated with health, money, honor, courtesy, the spring and vegetation. As a symbol of nature, it has been adopted by the "green movements", which defend the environment. It inspired a famous verse by the Spanish poet Frederico García Lorca, who in his *Romance sonámbulo* (Sleepwalker's Ballad), wrote: "Green, how I want you green/ green wind/ green branches." Along the same lines, the Colombian writer Aurelio Arturo, employing a poetic license to be colorblind, described Colombia as the country "where green is in all the colors." The Spanish word, *verde*, comes from the Latin *viridis* ("that which has sap"). Green shines forth in the botanical garden of Medellín, the stone terraces of the pre-Colombian site known as la Ciudad Perdida (the Lost City), the banana plantations of Sucre, the aquatic plants of the Amazon and the Laguna Verde of the Azufral volcano.

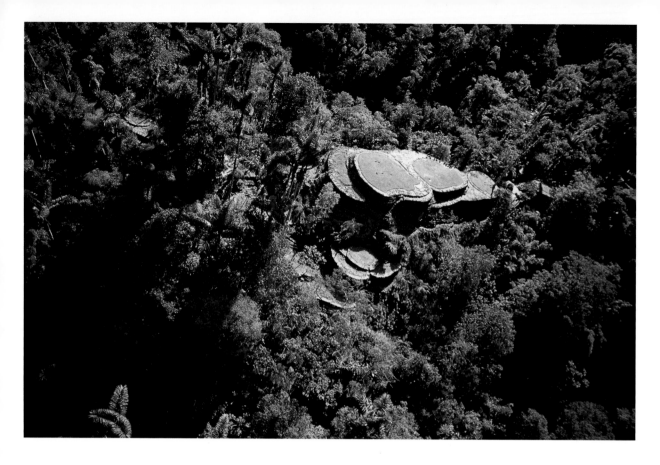

Ciudad Perdida – The Lost City

Teyuna is the archaeological park surrounding the Ciudad Perdida in the Sierra Nevada de Santa Marta. At an altitude of 1 100 meters above sea level, alongside the River Buritaca, it is one of the most important pre-Colombian ruins in South America, marked by a series of stone agricultural terraces, retaining walls, paths, stairways and canals.

Río Zabaletas, Valle del Cauca

This tributary of the River Anchicayá is born on the heights on the Western Cordillera, in the zone of el Dagua, and is the northern border of the city of Cali's Farallones Natural National Park. It flows through humid sub-Andean forests with majestic trees and thick undergrowth.

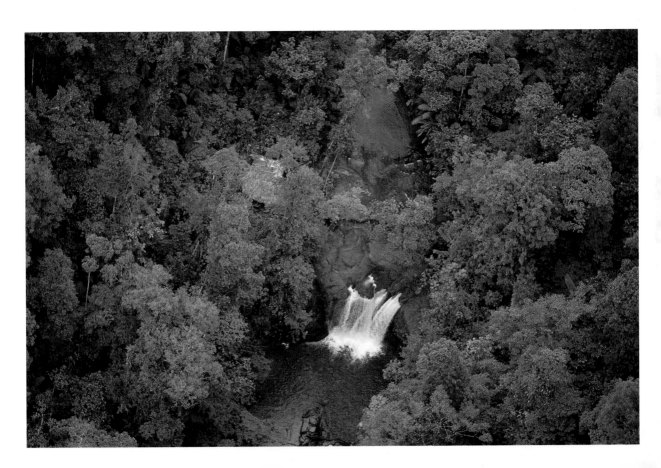

Ruitoque Golf Club, Santander

Located on the outskirts of the city of Bucaramanga in a terrain of rocks and cliffs, its landscaping features tall *jarapo* trees which are the home of birds like the swallow-tailed kite, canary and white eagle. An early morning round, when the mountain mists cling to the ground, is like "playing golf in the clouds," say its members.

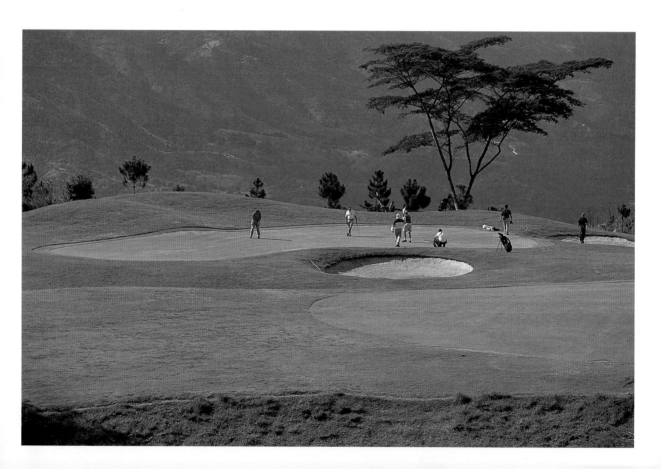

El Cocuy, Boyacá

The rural outskirts of this municipality are made up of small-holdings, where, because of the steep terrain, a yoke of oxen is still an indispensable tool. Along with potatoes (the staple of Boyacá cuisine), local farmers grow maize, wheat, barley and onions, and also rear cattle.

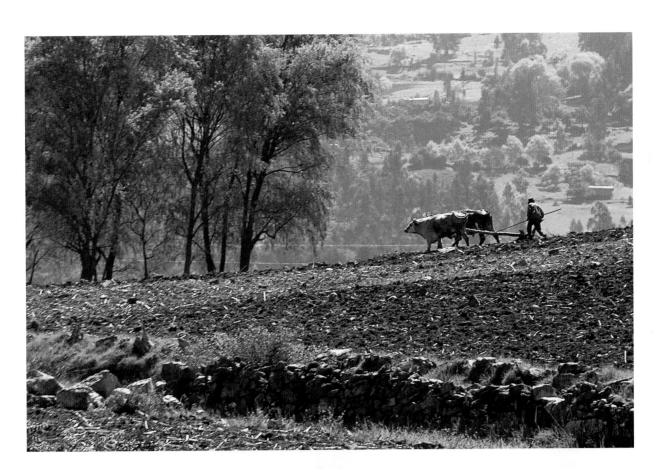

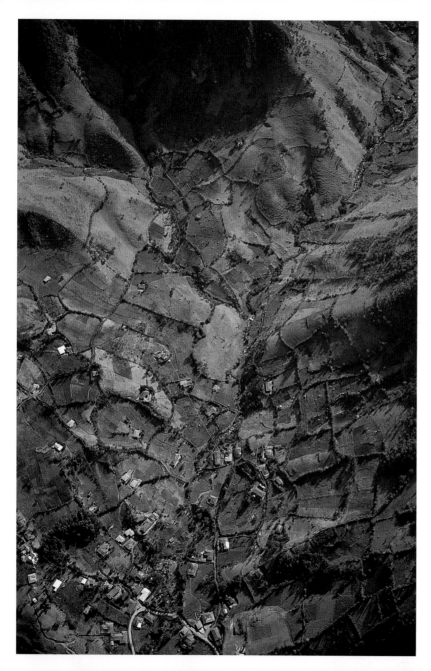

Rural surroundings of Silvia, Cauca

Silvia is a town in a territory known as Guambía, the ancestral homeland of the Guambiano peoples. It is located on the western flank of the Central Cordillera, at an altitude ranging from 1800 to 3800 meters above sea level. In recent decades, its environment has been threatened by large-scale cattle raising, the felling of forests and erosion.

River Casanare, Department of Meta

This, the most important tributary of the River Meta, is the border between the Departments of Arauca and Casanare. It is born in the Sierra Nevada del Cocuy and becomes navigable and rich in fish when it descends to the prairies. Among its riverside ports are San Salvador, Puerto Rondón and Cravo Norte.

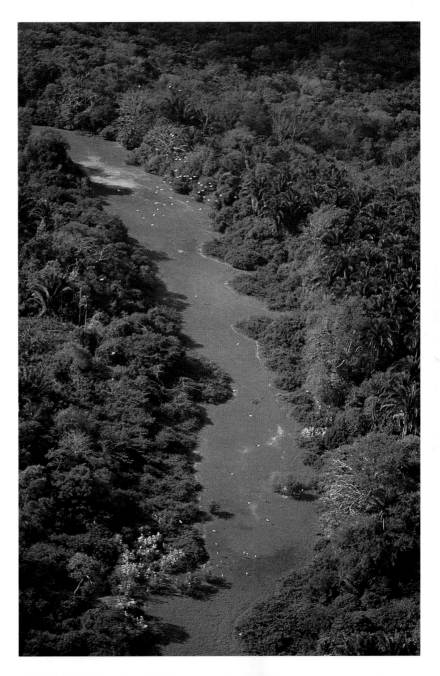

The Victoria Regis, Department of Amazonas

This aquatic plant, sometimes called the "flower of America," is sacred for the indigenous peoples of the Amazon. It belongs to the Nympheaceae or water-lily family, has a single giant leaf whose diameter may reach two meters, very fragrant white or pink flowers and a globular fruit.

Stone-paved path in Ciudad Perdida, Magdalena

The "Lost City" of the ancient Taironas was discovered in 1976 and later excavated. It is part of a vast complex of archaeological sites, of different sizes, that reach from the Caribbean coast to the heights of the Sierra Nevada de Santa Marta and were connected, in pre-Colombian times, by an intricate network of paths made of slabs.

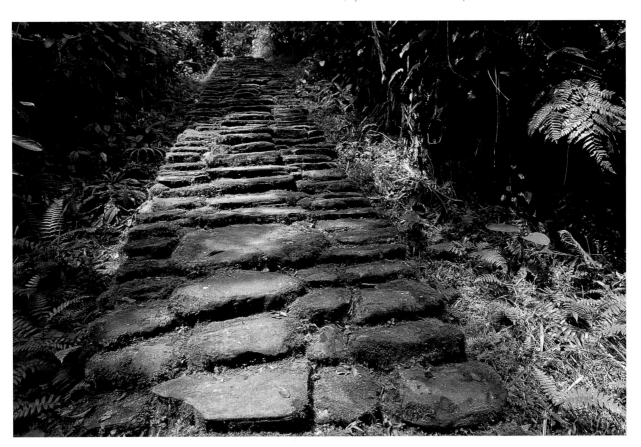

Los Katíos National Natural Park, Chocó

This nature reserve, which is a crossroads for species from Central and South America, is located in the Darien Gap and includes the Tumaradó marshes. A tropical rainforest zone, with one of the world's highest indexes of biodiversity, it was declared a Natural Patrimony of Mankind site by the Unesco in 1994.

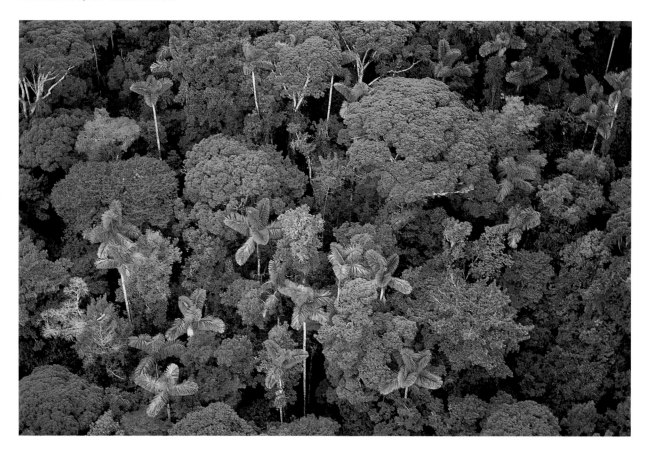

Groves of Guadua-Bamboo, Manizales, Caldas

The *guadua*, *Guadua angustifolia*, is a traditional building material now being put to use by avant-garde architects because of its lightness, strength and versatility. Its growth is also encouraged for environmental reasons: it conserves the soil, controls erosion, protects streams and is a home for birds and insects.

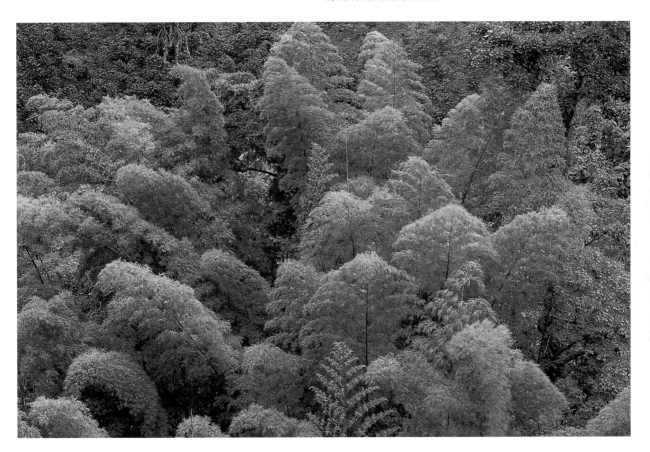

Tibaná, Boyacá

This town is located some 36 km from the city of Tunja and lies on the high plains of Cundinamarca and Boyacá, in the province of Márquez. In addition to agriculture and stock-raising, it has rich mineral resources, such as coal (in the district of Chiguatá), phosphates, sand and the clay used in the brickyards of the Lavaderos district.

The celebrations begin with the procession of the "Nazarenes," which represents Jesus's entrance into Jerusalem with the twelve disciples. It passes along the calle del Medio to the church of la Concepción, accompanied by crowds of worshippers carrying palm branches.

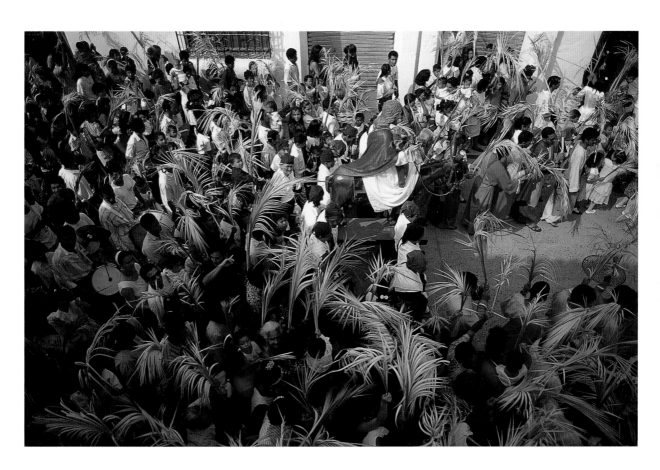

Tobacco field, Neiva

In the 19th century, when tobacco was an important export crop, it was mostly grown in the Department of Santander, which continues to be the main producer of the black variety. Nowadays, however, Huila is the country's third producer of the blonde variety after Boyacá and César. Tobacco is also grown in the valley of the River Magdalena.

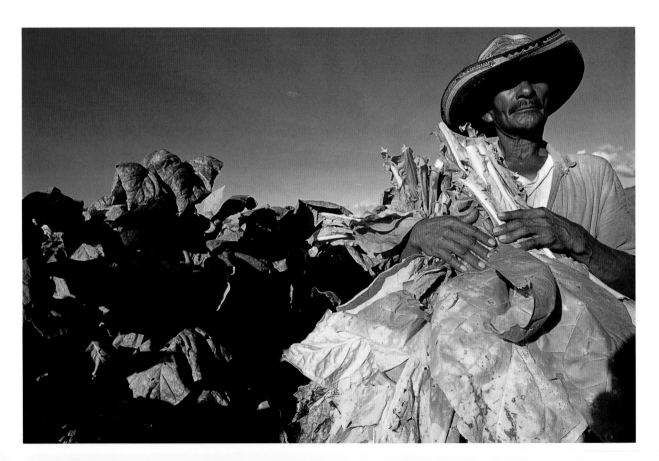

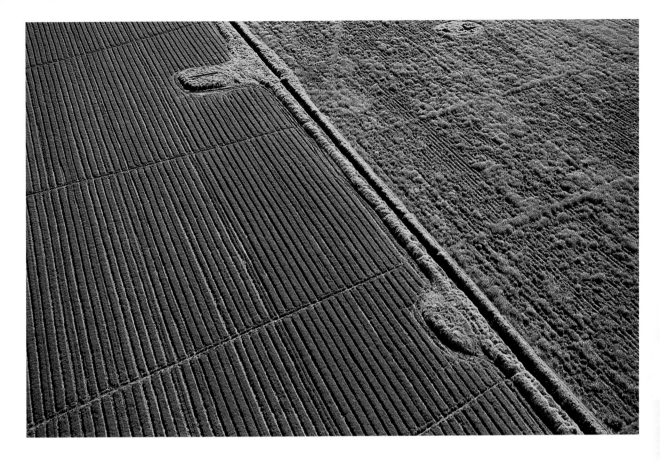

The Savanna of Bogotá

The fertile lands, mild climate and abundant streams of the savanna region that surrounds Bogotá greatly impressed the conquistadores. The products of the great haciendas in colonial times — milk, barley, wheat and vegetables — are still important, but they have been joined by intensive-flower growing, an important export industry.

Armenia, Quindío

The growing of coffee depends on the shade furnished by other plants, such as low-level tomato and medium-height *lulo*-fruit plants. But the most common is plantain, the traditional complement to coffee, which provides shade, fruit and organic fertilizer.

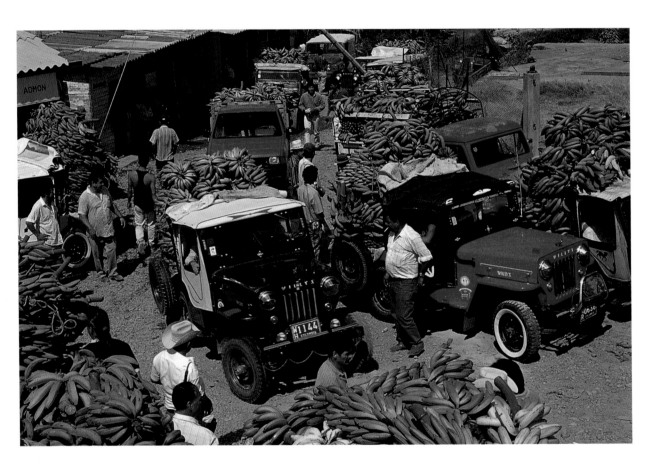

Quibdo, Chocó

The River Atrato serves as a commercial highway for Quibdo and its sur-
roundings. It is along this and other waterways that produce reaches the
cities. The high rainfall make agriculture difficult there, but the area does
produce plantain, maize, rice, cacao-beans and coconuts.

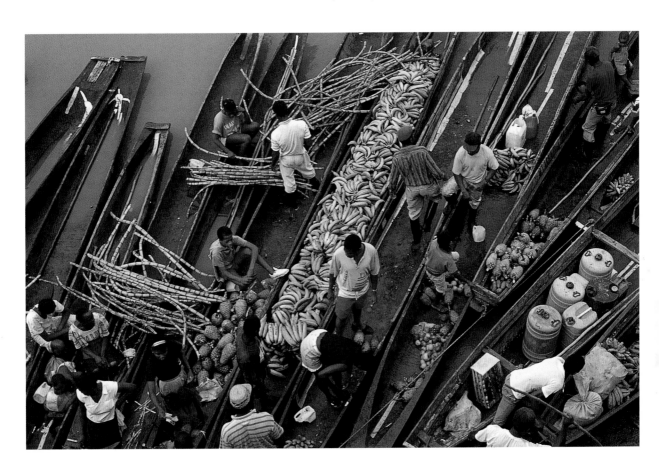

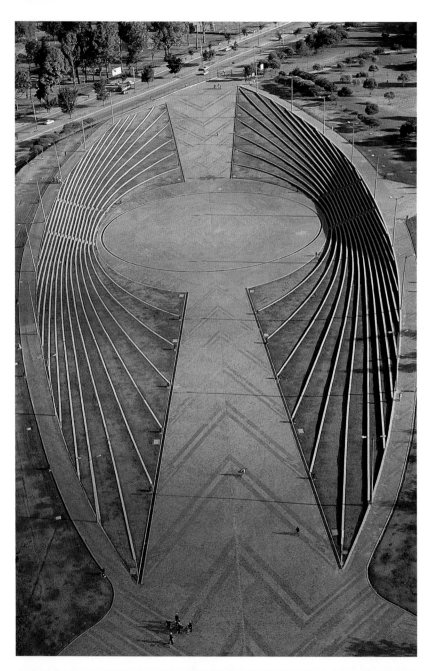

Simón Bolívar Park, Bogotá

In 1979, the Mayoralty of Bogotá set aside 400 hectares for a park and recreational area, which now includes the Novios and Salitre parks, the Children's Museum and a sports complex. The plaza shown here, built in 1983, is a site for different events and can accommodate 80 000 spectators.

Parque Nacional, Bogotá

Named after Enrique Olaya Herrera, the Colombian president who in-
augurated it in 1934, the "National Park" has the shape of a rounded tri-
angle, the top of which is seen here. It includes an assortment of sports
fields and facilities, gardens, paths, fountains, a pergola, a children's
theater and a clock-tower donated by the Swiss community in 1954.

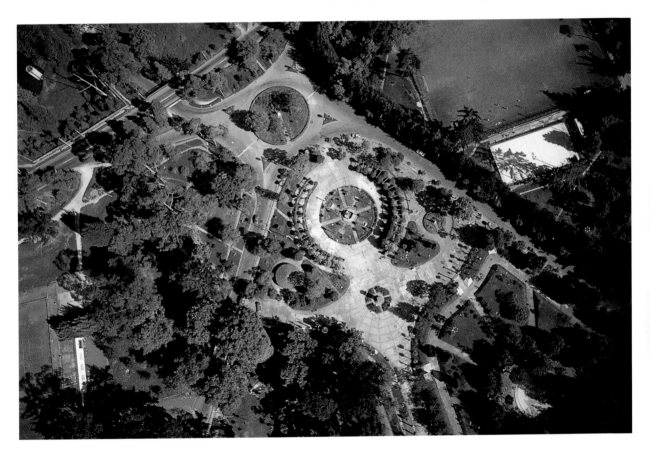

Tota Lake, Boyacá

The largest sweet-water lake in Colombia, it lies along the Eastern Cordillera, at an altitude of 3 015 meters above sea level, has an area of 55 km² and a depth of 60 meters. The San Pedro, Cerro Chiquito and Santa Helena islands adorn the lake, which is a place where people fish for rainbow and salmon trout.

Umbita, Boyacá

Most of the territory of this municipality, located in the Province of Márquez in the central part of the Department of Boyacá, is a cold, highland terrain, a third of it a paramo zone which includes the 2 800 meters-high Guanachas Municipal Natural Park, rich in water resources.

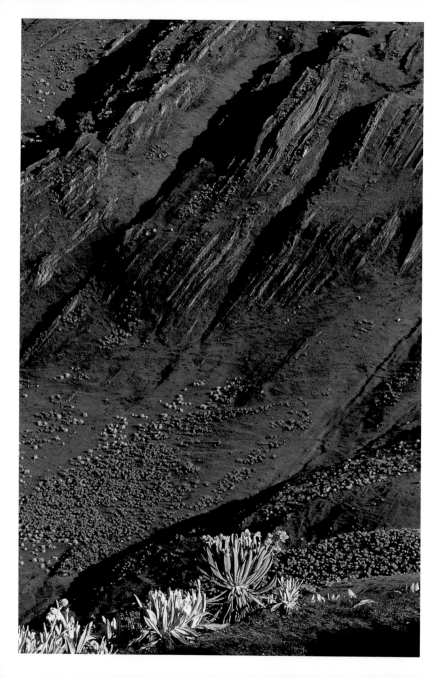

Páramo de Chingaza

The name of this high Andean moorland comes from the Muisca indigenous language, and is a compound of the words *Chim* (God), *gua* (mountain range) and *za* (night), that is the "Range of the God of night." Now a National Natural Park and the site of a reservoir that supplies Bogotá with most of its drinking water, it was a sacred place for the ancient Muiscas, who cast gold offerings into its lakes.

Sierra Nevada del Cocuy

This National Natural Park has 150 highland lakes. The River Lagunillas entwines the glacier lakes of La Parada, La Pintada, La Cuadrada and La Atravesada. Another lake, the Laguna Grande de la Sierra, stands at the foot of seven show-covered peaks, while still another, La Plaza, lies in the middle of a spectacular natural amphitheatre.

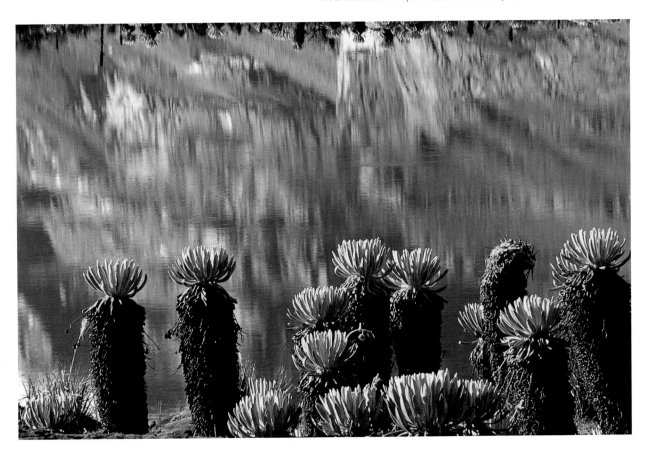

El Cocuy, Boyacá

According to the historian Javier Ocampo, the word *ruana* (the Colombian style-poncho) comes from Rúan, a French town where the Spanish bought their cloaks. In the Muisca language, Boyacá means "the land of cloaks," which gives an idea of the importance of a traditional garment which is still manufactured by hundreds of local families.

Chinauta, Cundinamarca

Three articles used by almost all of the country people in Colombia are the *ruana*, which is thought to be a cross between the Chibcha poncho and the Spanish cape; the straw hat, usually made of *jipijapa* palm fiber; and the walking stick made of *ayuelo* or *guayacán* wood, which often has an iron tip.

Aquarium, Islas del Rosario, Department of Bolívar

Founded some 15 years ago, and located on the island of San Martín de Pajarales, it displays more than 40 species of marine fauna, including dolphins, sharks, groupers, sting-rays, sawfish and giant turtles. It is also a center for environmental protection.

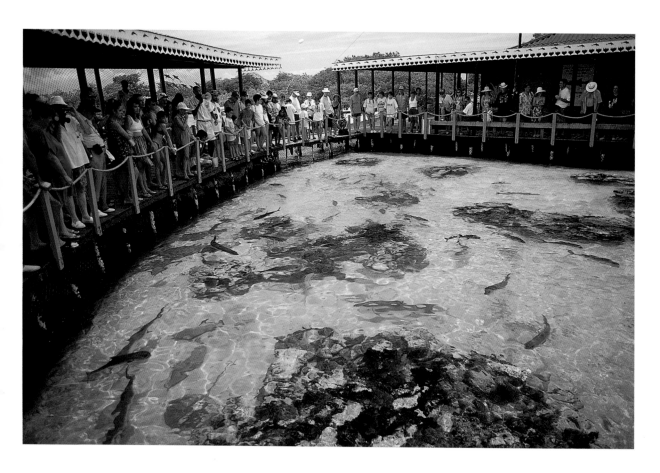

Hot springs, Puracé Volcano

Situated in the heart of the Colombian Massif, the Puráce National Natural Park counts on two types of hot springs: the sulphurous, acid waters of the River Vinagre (Vinegar River) and the salty, sulphurous waters issuing from the outcrops of Pisimbalá, which may reach a temperature of 22 ºC.

Manizales, Caldas

Detail of *Bolívar Cóndor,* a sculpture by the Colombian artist Rodrigo Arenas Betancourt, of forged bronze on an 18 meter-high concrete base. It stands in the Plaza de Bolívar, which is also the site of the cathedral and the offices of the departmental government.

Emeralds, Boyacá

The Spanish word for *Esmeralda* comes from the Latin *smaragdus*, which means "green." Colombian emeralds are known all over the world for their exceptional purity, color and size. The main emerald-bearing veins are found in Muzo and Coscuez in Boyacá, and in Chivor and Gachalá in Cundinamarca.

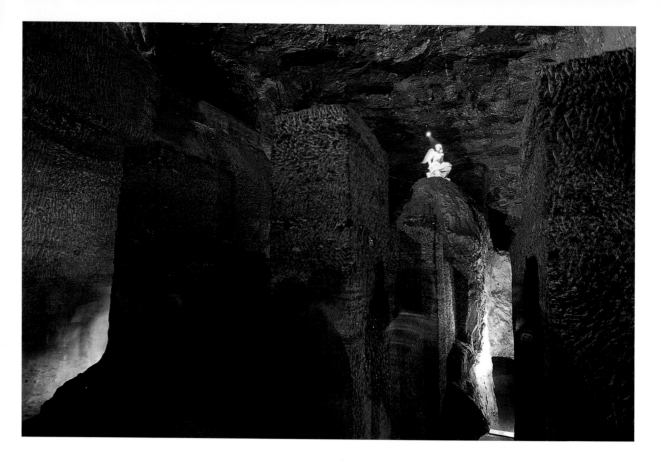

The Salt Cathedral, Zipaquirá

The ancient Chibchas obtained salt by evaporating the salty waters issued from this mountain. In 1801, Humboldt, on his visit to Colombia, recommended the subterranean exploitation of the salt. The Cathedral was dug out of the salt mines and is considered to be an outstanding achievement of Colombian artistry and engineering.

Christmas lights, Medellín

During the December fiestas, the Río Medellín is turned into a sea of lights and colors, organized by the Public Services Company of Medellín (EPM). This "filigree work" involves the use of electrical cables, metal structures, projectors and bulbs.

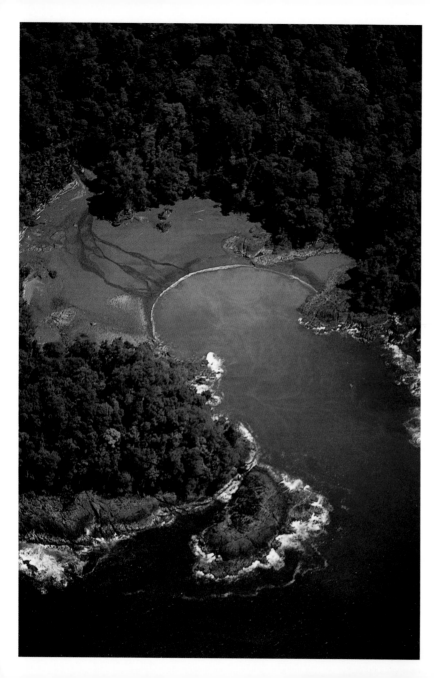

Bahía Solano, Chocó

The Gulf of Cupica has the shape of an inverted "C" at the southern end of which lies the town of Bahía Solano, also known as Ciudad Mutis. Hemmed in by the foothills of the Baudó mountain range, it has a hot, wet climate and is one of the most beautiful tourist attractions in Colombia.

Islands of San Bernardo, Córdoba

This archipelago lies in front of Tolú, to the southeast of the gulf of Morrosquillo, and is made up of 10 small islands, formed from the tips of coral reefs, which barely emerge from the sea and have mangroves and other salt-tolerant plants.

Guaicaramo Hot Springs, Barranca de Upía, Meta

The first conquistador to reach the Llanos Orientales was the German Jorge Spira, who in 1538 had to wait eight months on the steep banks of the Upía for the level of the river to fall before continuing his journey. An ancient crossing for man and beast, it played a crucial role in the battles of the Independence and the War of a Thousand Days.

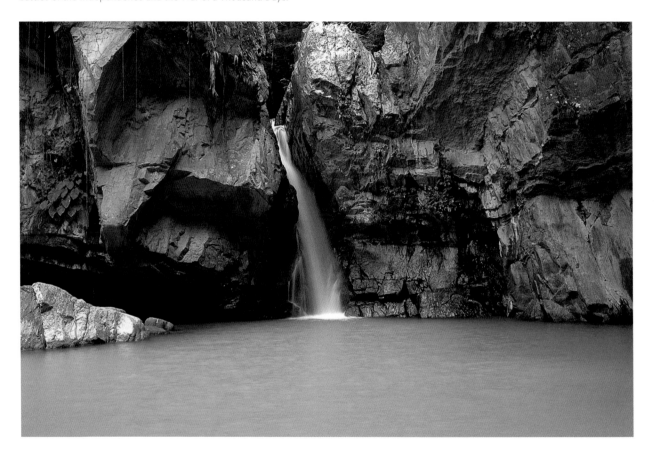

Laguna Verde, Azufral Volcano, Nariño

The astonishing "Green Lagoon" lies in the crater of the Azufral Volcano and has acid waters that are boiling and freezing at the same time. Situated at an altitude of 3 765 meters above sea level, it is surrounded by white sand and sulphur deposits. At the foot of the volcano one finds the high plain and the city of Túquerres, at a distance of 12 km.

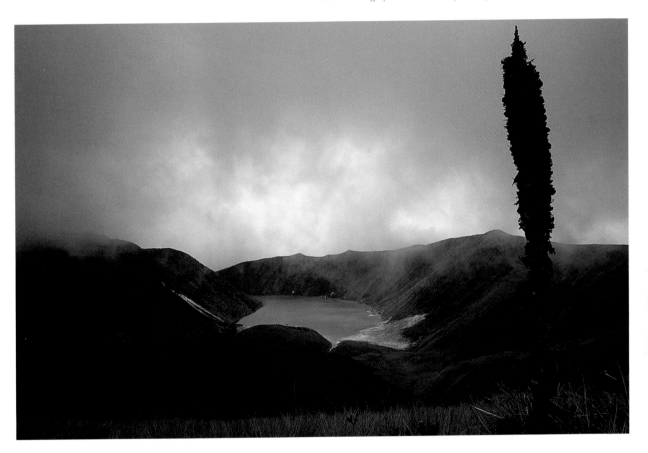

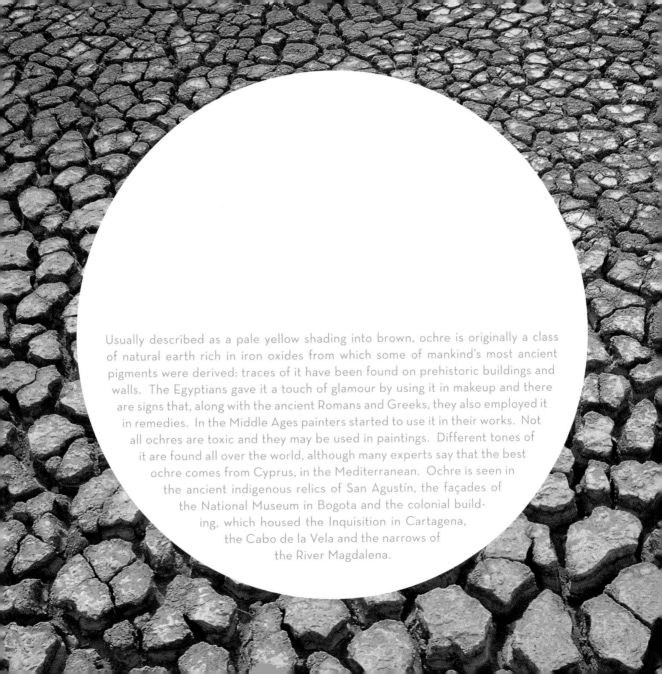

Usually described as a pale yellow shading into brown, ochre is originally a class of natural earth rich in iron oxides from which some of mankind's most ancient pigments were derived: traces of it have been found on prehistoric buildings and walls. The Egyptians gave it a touch of glamour by using it in makeup and there are signs that, along with the ancient Romans and Greeks, they also employed it in remedies. In the Middle Ages painters started to use it in their works. Not all ochres are toxic and they may be used in paintings. Different tones of it are found all over the world, although many experts say that the best ochre comes from Cyprus, in the Mediterranean. Ochre is seen in the ancient indigenous relics of San Agustín, the façades of the National Museum in Bogota and the colonial building, which housed the Inquisition in Cartagena, the Cabo de la Vela and the narrows of the River Magdalena.

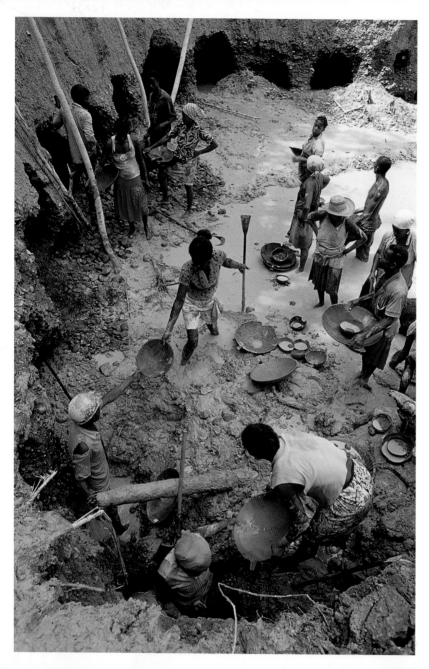

Extraction of gold, Chocó

The Chocó is the country's main producer of gold and platinum. Gold exploitation goes back to the 16th century, when African slaves worked the mines. It is still a major economic activity in the region, where there is a mixture of artisanal techniques and the use of modern dredging equipment.

Fuente Lavapatas, San Agustín, Huila

This "foot-washing fountain," located in the mountains of Huila, is one of the archaeological treasures of Colombia. Carved out of the stony bed of a stream, it was probably a sacred site for the pre-Colombian cultures. The water runs along a series of falls, pools, ponds and channels in the shape of zoomorphic figures.

National Capitol building, Bogotá

This sober and elegant colonnade marks the entrance of the Capitol, located on the Plaza de Bolívar, and leads to the Mosquera courtyard, named after General Tomás Cipriano de Mosquera, who, as president of Colombia, commissioned its design from the Danish architect Thomas Reed in 1846. Its construction was not completed until 1926.

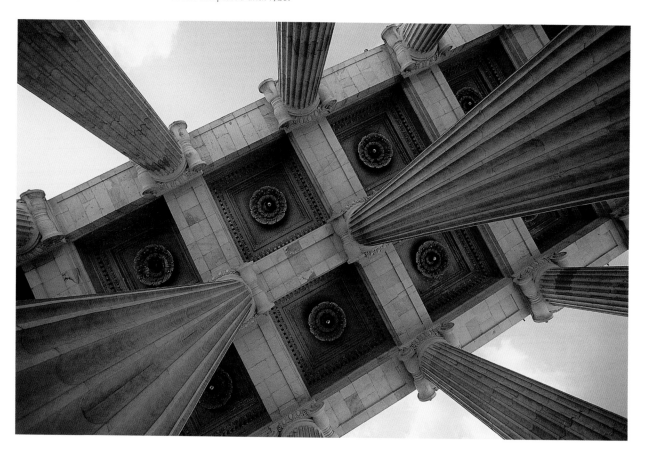

Palacio de la Inquisición, Cartagena

It is considered to be the best example in the country of 18th century baroque civil architecture. The façade, with its imposing stone doorway, grilled mezzanine and upper balconies, occupies one whole side of the Plaza de Bolívar. It now houses the Cartagena Academy of History, History Museum and Archives.

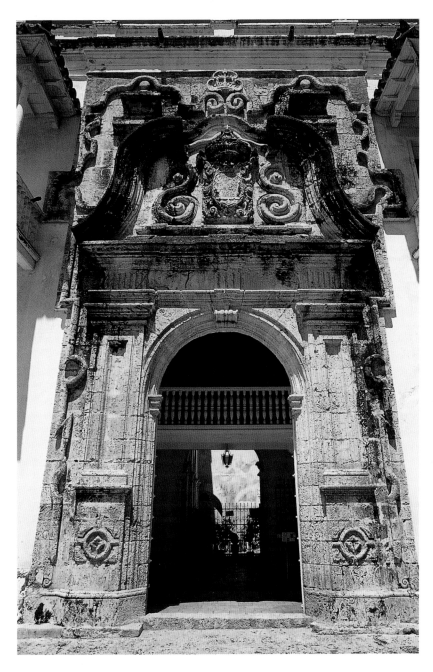

Bakery, Bucaramanga, Santander

Some investigators believe that the advent of European-style wheat-bread goes back to the Germans who settled in Santander in the 19th century, though the more traditional use of maize still flourishes. Santander boasts of one of the country's most varied and highly-elaborated cuisines.

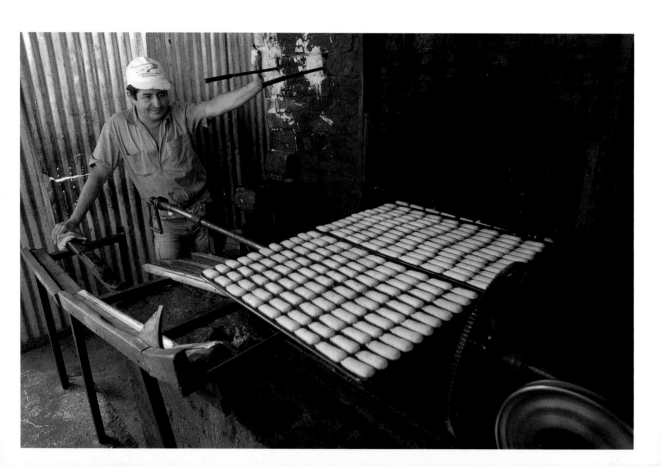

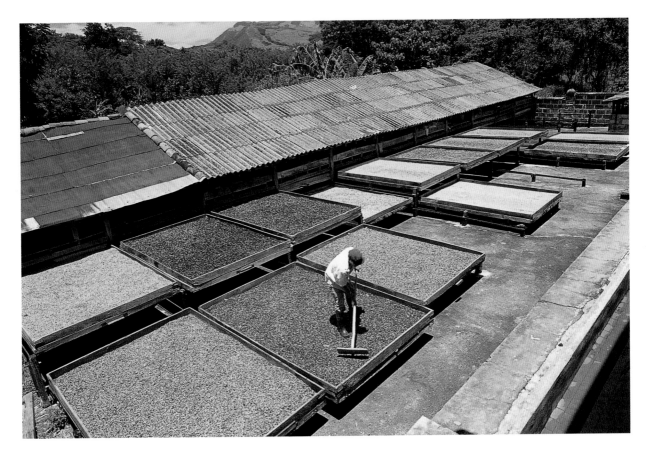

Coffee-drying yard, Bolombolo, Antioquia

This stage of coffee-production is meant to reduce the bean's moisture, so that it may be safely stored. Some places use mechanical dryers, but the tradition of hand-drying in the sun is still strong. The beans are spread over low wooden platforms in very thin layers and turned over at least four times a day.

Chapel, Jardines de Paz cemetery, Medellín

This chapel of the Assumption in the "Gardens of Peace" cemetery was designed by the architects Felipe Uribe, Mauricio Gaviria and Héctor Mejía and won a prize at the Colombian Biennial of Architecture in 2000. It combines natural lighting, white concrete, glass and iron to create a solemn and peaceful atmosphere.

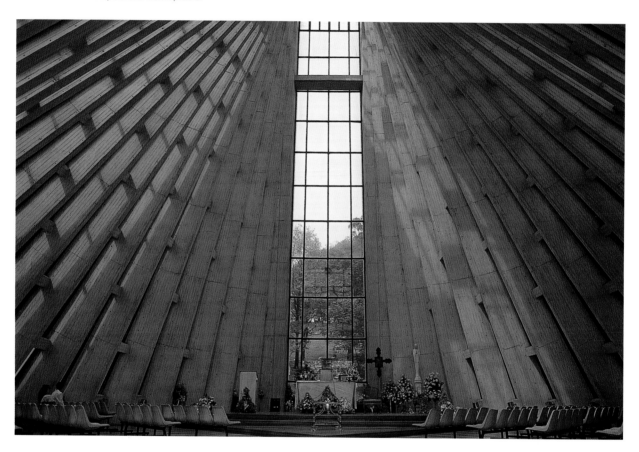

Headquarters of the
Public Services Companies of Medellín

The EPM, the country's biggest public services enterprise and a technological leader in South America, inaugurated this "intelligent" building in 1997. It was designed by Marco Aurelio Baquero, Carlos Julio and Carlos Eugenio Calle.

Island of Malpelo

This, the main island of an archipelago, descends to a depth of 4 000 meters in the sea. Its highest point, the Mona ridge, reaches an altitude of 300 meters above sea level. It is surrounded by 11 islets: the four Mosqueteros on its northern edge; Vagamares and La Torta to the east; and five on its southern edge: the three Reyes, La Gringa and Escuba.

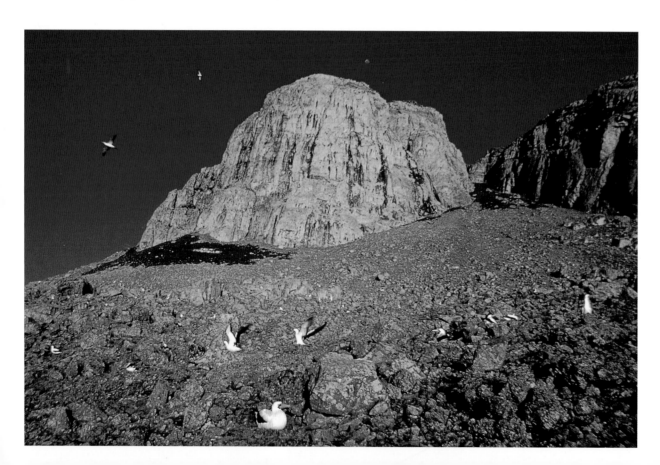

Desert of La Tatacoa, Huila

This desert lies 40 km from Neiva, on the right bank of the River Magdalena in the municipality of Villavieja. It has an area of 330 km², attracts students of paleontology and archaeology and because of its clear skies and location, serves as a natural astronomical observatory.

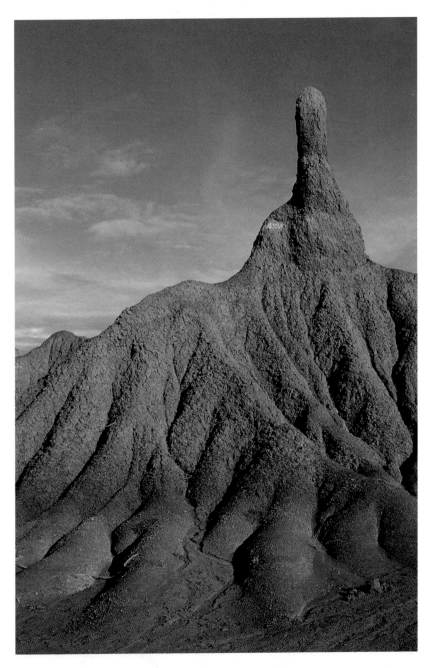

Traditional Wayuu hut, Maicao, Guajira

A *ranchería* is a traditional Wayuu settlement, made up of five or six houses, a corral for goats and a garden. The houses are square or semi-circular, with mud or mortar walls and roofs woven from *yotojoro*, the dry heart of the cactus, though the use of zinc rooftiles is now spreading.

Quibdo, Chocó

The River Atrato is both a highway and an inexhaustible source of food for the inhabitants of the Chocó. Sardines, *guacuco*, *mojarra*, *micuro* and *rollizo* are among the ones most commonly caught there. The Atrato is a river with one of the world's strongest flows.

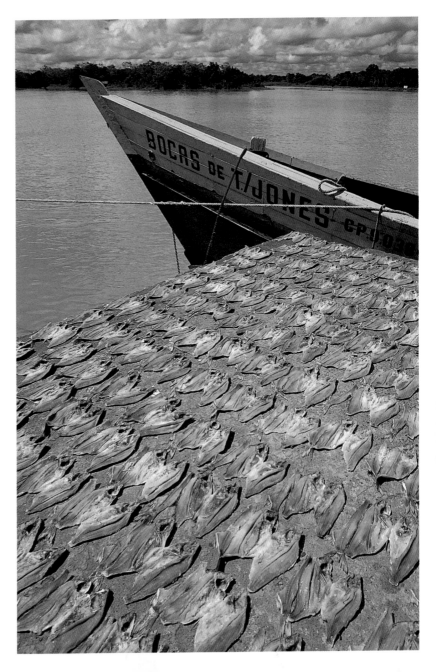

La Macuira National Natural Park, La Guajira

The Macuira range is a green oasis in the middle of the desert of La Guajira. For such a small area, it boasts of an astonishing variety of ecosystems, including dwarf evergreen cloud forest, tall riparian forest along the gullies, dry deciduous forest and semi-desert.

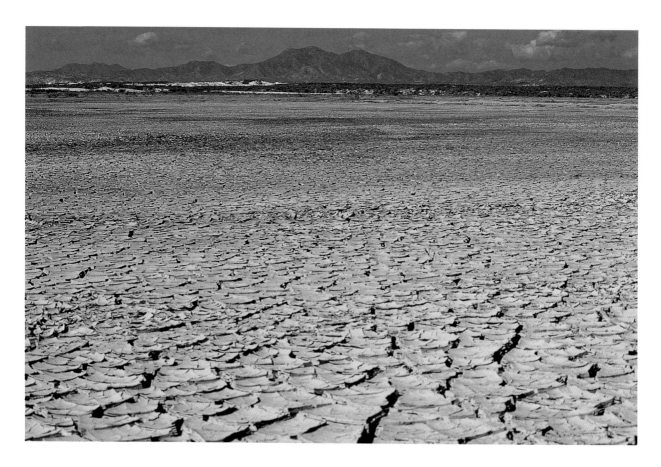

Cabo de la Vela, La Guajira

Cabo de la Vela (Sail Cape) is the northern-most point of South America. According to the Wayúu indigenous people this place is "the path of souls," where the spirits of the dead begin their journey to the unknown. This beach, surrounded by desert, is a popular tourist attraction.

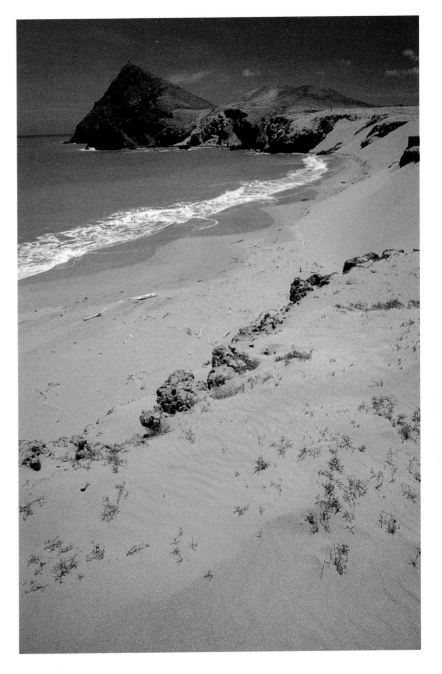

Taminaca, Sierra Nevada de Santa Marta, Magdalena

This traditional settlement of the Kogui indigenous group lies in the valley of the río Palomino on the northern foothills of the Sierra Nevada and is a center of their community and spiritual life. Descendants of the ancient Taironas, they conserve their language and many of their old customs.

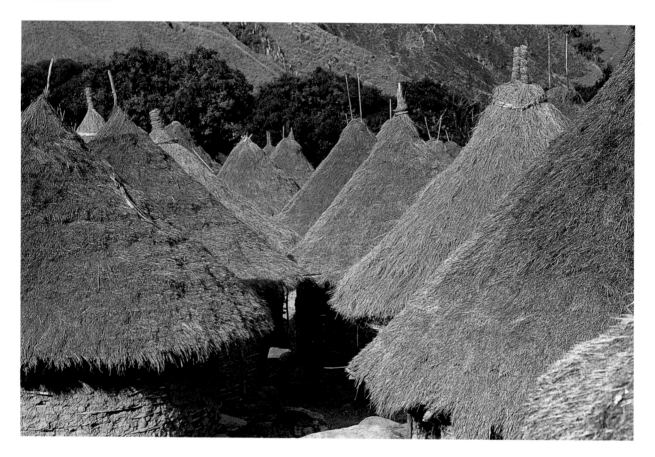

Bell workshop, Nobsa, Boyacá

This municipality in Boyacá is known for three activities: wine-growing, whose quality is steadily improving; the manufacture of *ruanas*, the traditional poncho of Boyacá; and the bells seen here. It is a completely hand-made process, from the shaping of the moulds to the forging of the bronze at a temperature of 1 200 °C.

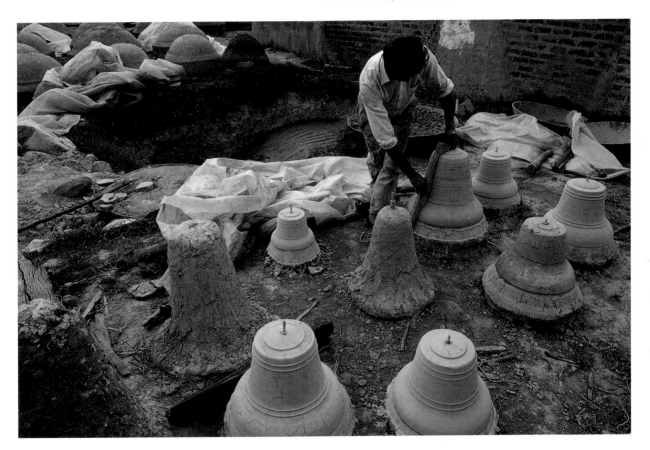

Núñez Patio, Capitol building, Bogotá

This courtyard, named after a 19th century president, Rafael Nuñez, was designed by Mariano Sanz de Santamaría. Work on it began in 1911 and it was inaugurated in 1920. From it you can see the new Congress building and the parade ground of the Presidential Palacio de Nariño. The bronze statue of Núñez is by the Colombian artist Francisco A. Cano.

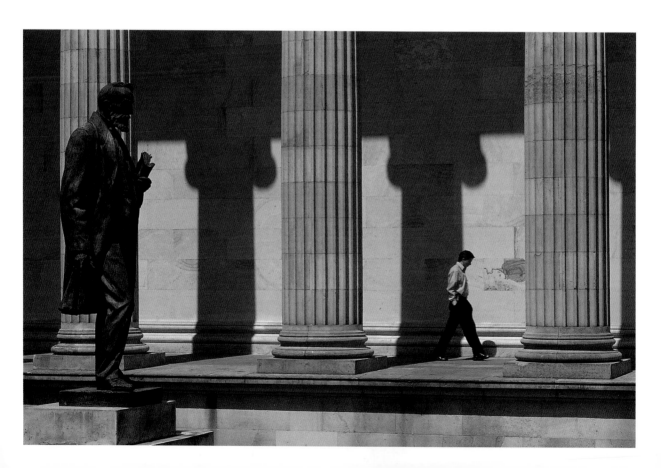

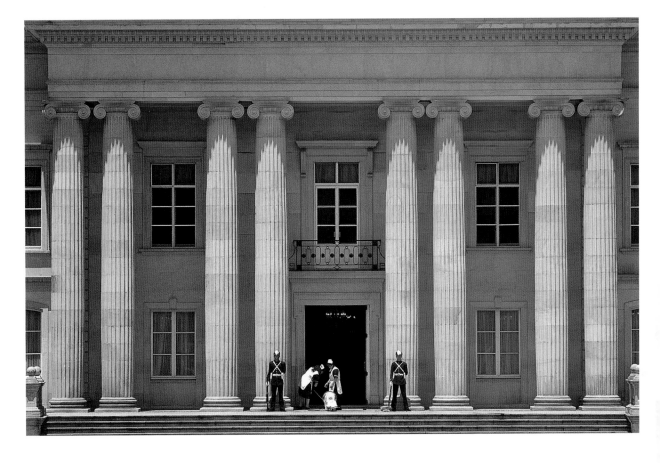

Casa de Nariño – Presidential Palace, Bogotá

The presidential residence stands on the site of the birthplace of Antonio Nariño, a Founding Father of Colombia. It has served this purpose since the late 19th century, sometimes alternating with the Palacio de San Carlos. Upgraded over the years, the current building (including the façade) is in the neo-classical style and was inaugurated in 1980.

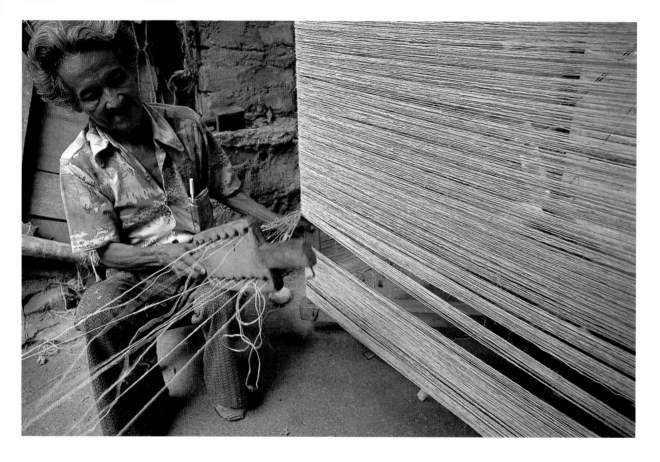

Vertical loom, Bucaramanga, Santander

The earliest looms were vertical ones, with the warp threads suspended from a branch or piece of wood. The weft threads would be pushed into place by hand or a stick that would eventually become the shuttle. Later, a rod was inserted to produce a space between warp threads, so so that the shuttle could pass through the entire warp at once.

Pottery wheel, Ráquira, Boyacá

This technique was brought by the Spaniards. The fresh clay is kneaded to remove bubbles, then it is centered round the wheel, which may be powered by a pedal or an electric motor. As it turns, one hands clasps the center, while the other piles up and shapes the clay, always taking care to keep it moist.

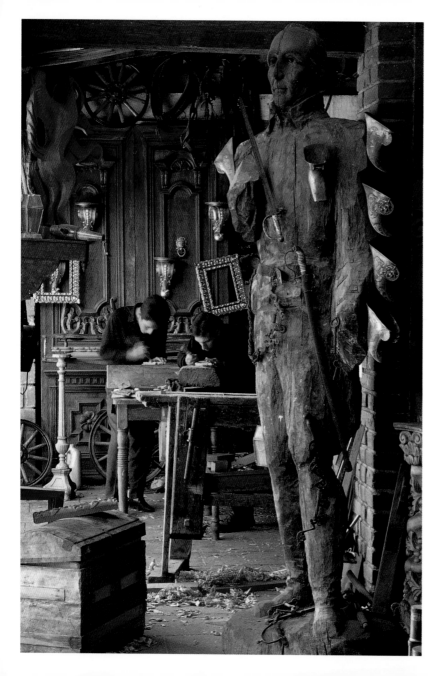

Cabinetmaker's workshop, Pasto, Nariño

The indigenous people from this region were already famous in the pre-Columbian period for their mastery of mopa-mopa, or Pasto varnish. Their skill as woodworkers and cabinetmakers was well known during the colonial period also, due to the influence of sculptors from Quito. Today, the tradition is carried on from father to son.

Saddle workshop, Belén, Nariño

The making of a saddle begins with the carving of the wooden saddle tree, which is then overlaid with wet leather which, as it dries, shrinks and gives solidity to the piece. The pommel and cantle are reinforced with iron and rings for the crupper and stirrups are attached.

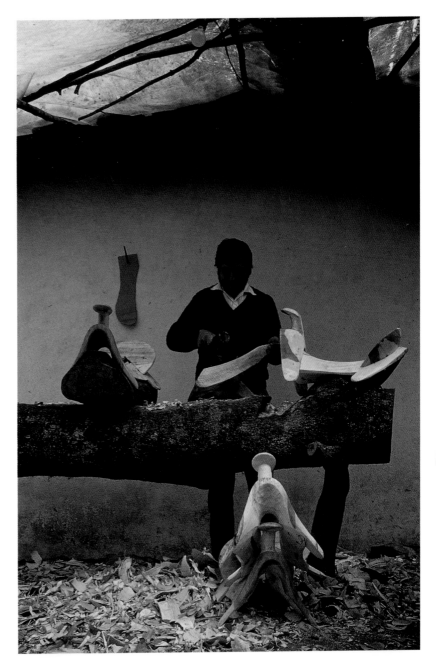

A bold mixture in which red and green predominate, with a persistent touch of orange as well, the color brown is a conjunction of innumerable wonders. Comfortable and severe, it is a color ussually associated with masculinity. It evokes ideas of gravity, balance and an autumnal atmosphere. Perhaps because it is the color of the earth, which everyone walks on, it is unquestionably the color of realism. In the controversial and often unyielding realm of dream interpretation, this color represents freedom, success, money, felicity and lasting relationships. The Spanish word, *café*, derives from the Italian *caffe*. It is a color that may be seen in the statues of the San Agustín archaeological park in the south of the country, the serranía de Macuira, the bell factory of Nobsa and the craftswork of Neiva, as well as the sugar mills of Consacá, the desert of the Tatacoa and the yards where coffee is dried in Bolombolo.

Colombiamoda fashion show, Medellín

This is the country's most important fashion show, held every July since 1989 in the Plaza Mayor convention center in Medellín. It includes runways, exhibits and conferences about the fashion industry. It is complemented by Colombiatex, held in January, which the trade show of the Colombian textile industry.

Muleteer, Bolombolo, Antioquia

Strong men who also colonized virgin lands and founded towns, the *arrieros* or muleteers of Antioquia were famous for the transport and trade of goods by mule. They are still to be found in mountainous regions of the department where there are no paved roads.

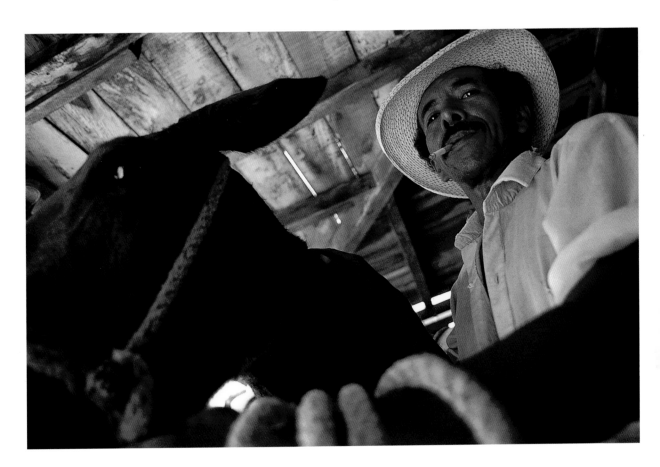

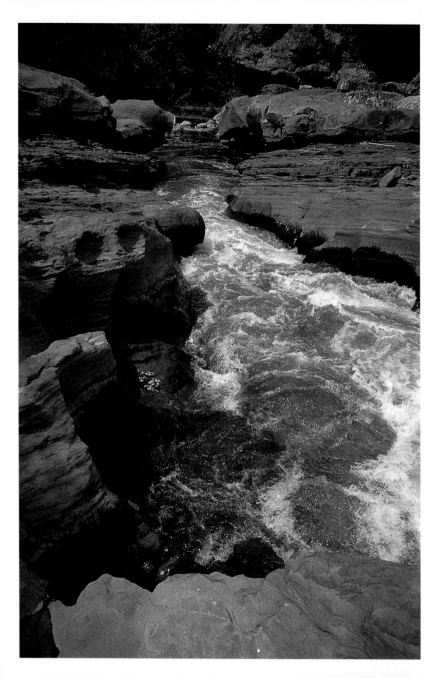

Narrows of the River Magdalena, Department of Huila

The river is born in the Magdalena lake, on the 3 350 meters-high paramo or high moor of las Papas, where the Eastern and Central Cordilleras divide. When it reaches the area of San Agustín, the river must pass through a narrow stone gorge known as the narrows of the Magdalena, which in places is no wider than 2.2 meters.

Maipures Rapids, River Orinoco,
Department of Vichada

Humboldt called this place, the center of the Tuparro National Natural Park, the Eighth Wonder of the World. Along a 6 km stretch, the Orinoco, as it falls, forms rapids, whirlpools and narrow channels that prevent navigation. According to an ancient legend, it was created by an indigenous woman, Mapiripana, to stop her beloved from running away.

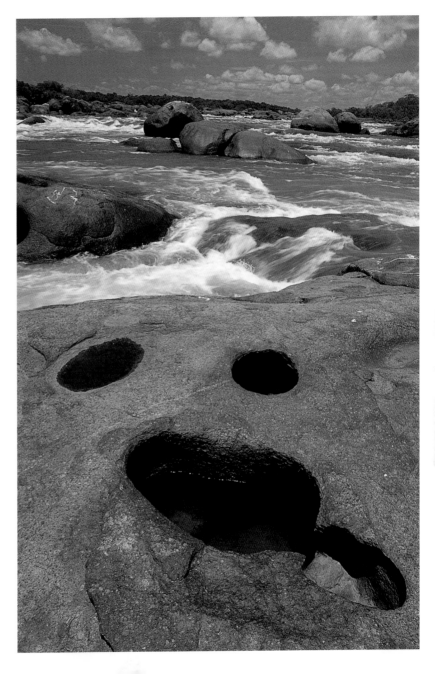

Mangrove swamp, Gulf of Utría, Chocó

This region, a National Park since 1987, is a nature reserve of world importance, due to its very rich biological diversity and large numbers of endemic species. A third of its total area is offshore. Located on the Pacific coast, it is bordered by the Baudó range, the source of the rivers which flow into it.

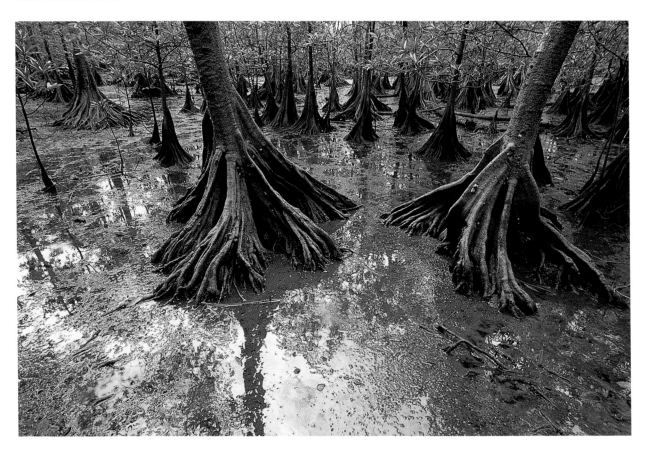

Artisanal brickworks, Tierradentro, Huila

Since the times of ancient Egypt, bricks made of clay have been a universal building material and their fabrication has changed very little over the centuries. Once they are molded, they are placed in ovens where conduits channel the fire into the chamber where they are baked.

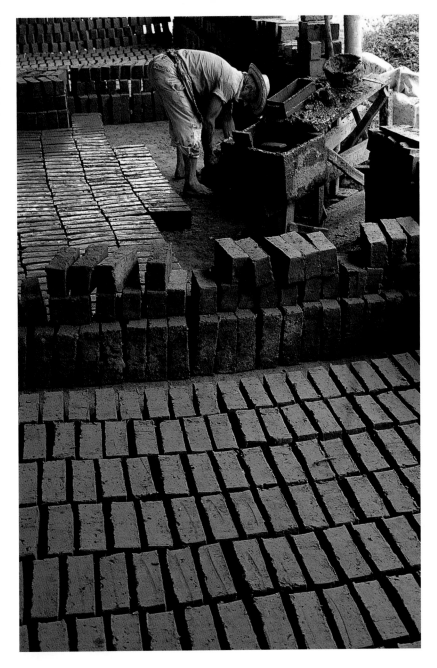

Pre-Colombian Hypogeum, Tierradentro, Huila

These ancient pre-Hispanic tombs were carved out of the subsoil and reach a depth of 9 meters. A spiral stairway leads to the interior and the chambers, roofs and columns are decorated with geometric and figurative designs in red, black, orange, gray, purple and yellow.

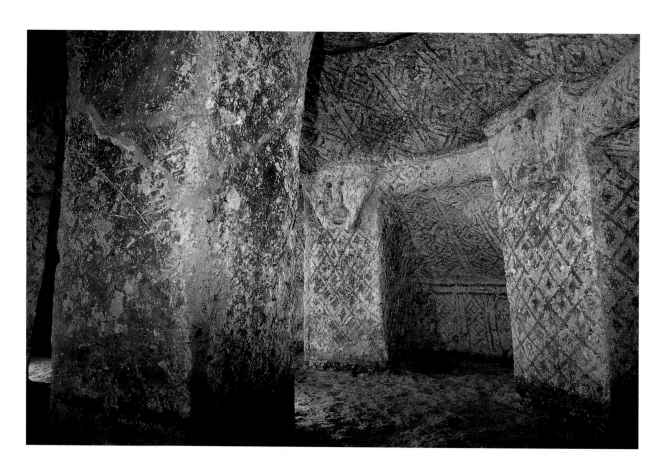

Pre-Colombian statue, San Agustín archaeological park, Huila

There are several theories about the origin of the San Agustín culture. However, at the time of the Spanish Conquest, the society which created these stone sculptures had disappeared and the indigenous inhabitants of the region knew nothing of their origins.

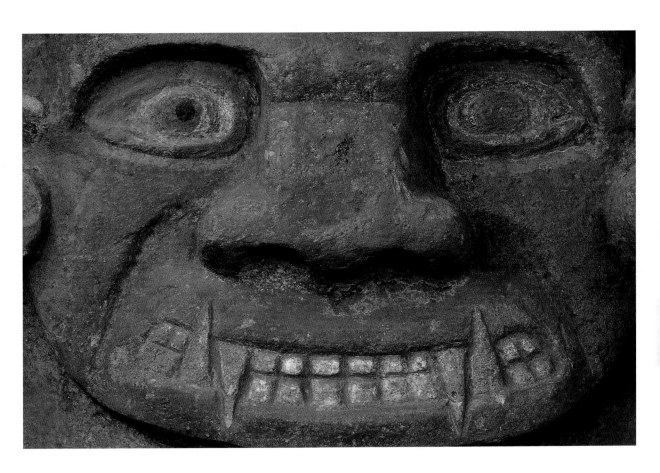

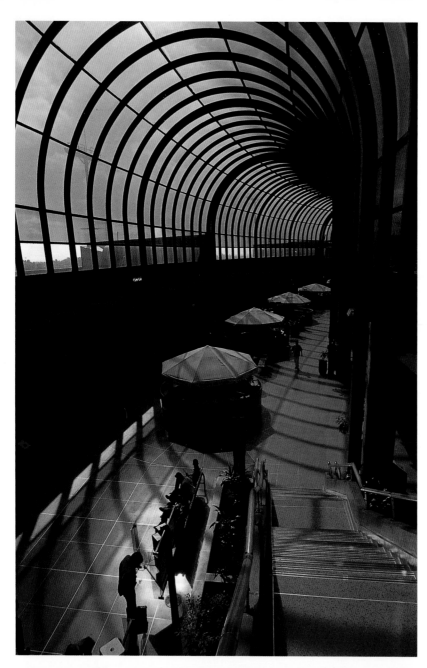

Rionegro Airport, Medellín

By 1980, it was becoming clear that Medellín's original airport, the Olaya Herrera, was no longer able to cope with the growing number of flights and passengers and work began on the José María Cordova airport in Rionegro, which was opened on August 29, 1985. Located 35 km from the city, at an altitude of 2 137 meters above sea level, it features an enormous dome over its lounges, counters, restaurants and stores.

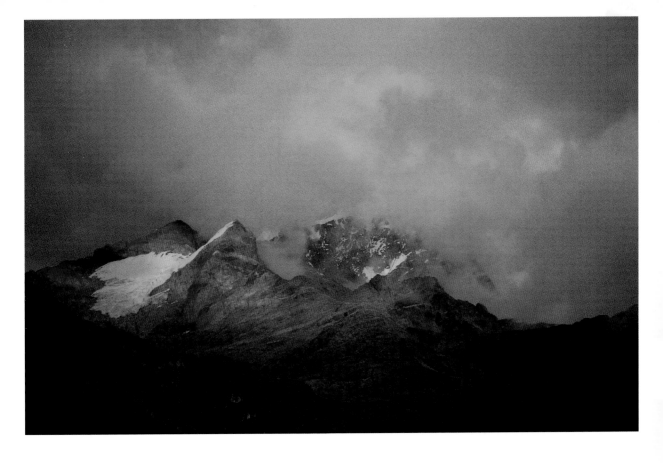

Sierra Nevada de Santa Marta

Ijka peak in the foreground and La Reina peak behind the clouds. The
Sierra Nevada de Santa Marta is the world's highest group of mountains
which do not belong to a range and are situated near the seashore. It is
inhabited by the Kogui, Arhuaco and Arsario indigenous groups, descen-
dants of groups who inhabited the Sierra for thousands of years.

Removing parasites from cattle, Llanos Orientales

Calfs are especially vulnerable to ticks, which may cause harm to their growth and the development of their bones. Certain races are more resistant than others to certain parasites: white, black-eared cattle stand up to botflies, while the humpbacked Cebús are more immune to ticks.

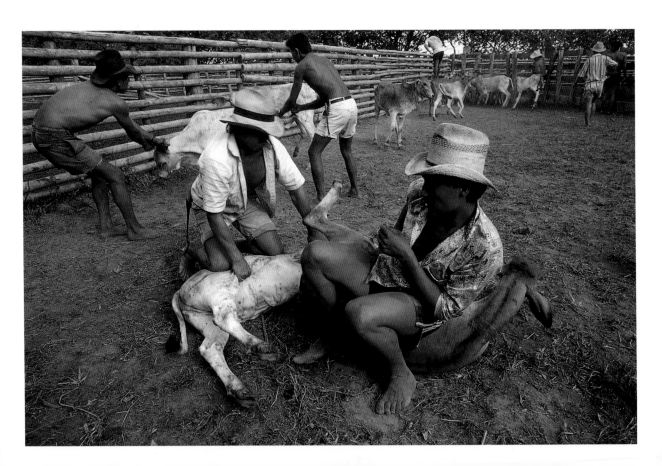

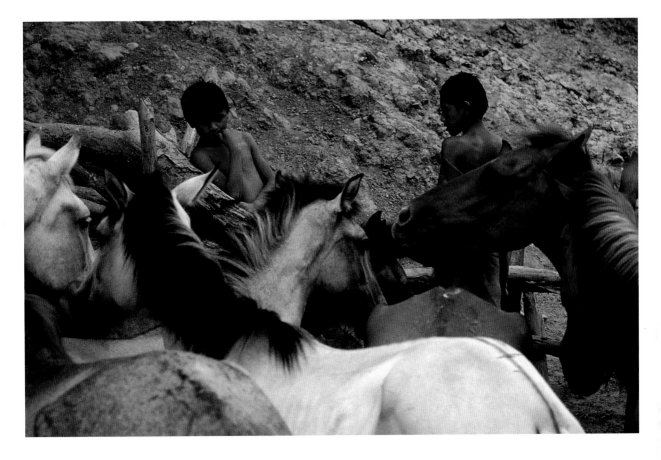

Ponies, Llanos Orientales

For the *llanero*, the inhabitant of the Eastern Prairies, the horse is a symbol of freedom. The *llanero* lancers of the republican armies played a crucial role in winning important battles of the Independence campaign, like those of the Pantano de Vargas and Boyacá. To this very day, the cowboys of the region spend their whole working day on horseback.

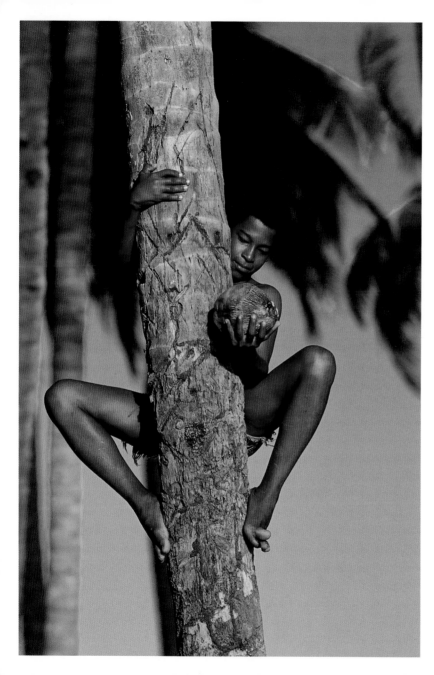

Island of Providencia

The Spanish discovered this island around 1500; it was the later a hideout for Dutch and English pirates. In the 17th century African slaves were imported to work in tobacco and cotton plantations. Their descendants speak English and are Protestants.

Street in Barichara, Santander

The streets, churches and cemetery of this town are made of yellow stones. The nave of its Immaculate Conception cathedral is upheld by 10 monolithic, 5 meters-high stone columns. Due to its well-conserved colonial architecture, its center was declared an historic monument in 1978.

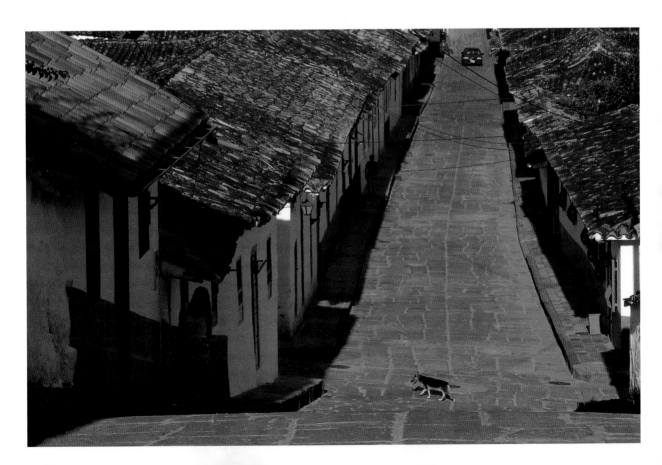

Shoeing a horse, Llanos Orientales

The hoofs of horses grew 2 cm each month, which is why they must be periodically trimmed. To give the hoof strength and prevent it from splitting, cracking or rotting, horseshoes are used, which must be cleansed daily. A clean, dry hoof prevents infections and helps the horse to maintain a good posture.

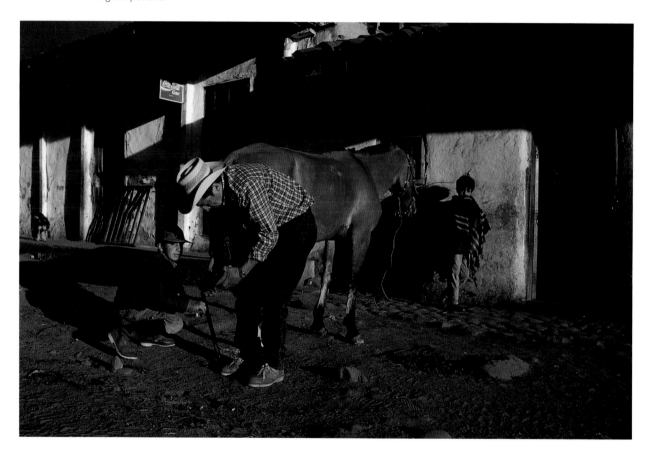

Driving cattle

Vaquería is the name for the job of managing cattle, part of which is driving them to fresh pastures, crossing creeks and gulleys on a horseback. It has given rise to a Colombian cowboy culture, which includes its typical food, dress, manners and music like the *galerón* and *joropo*.

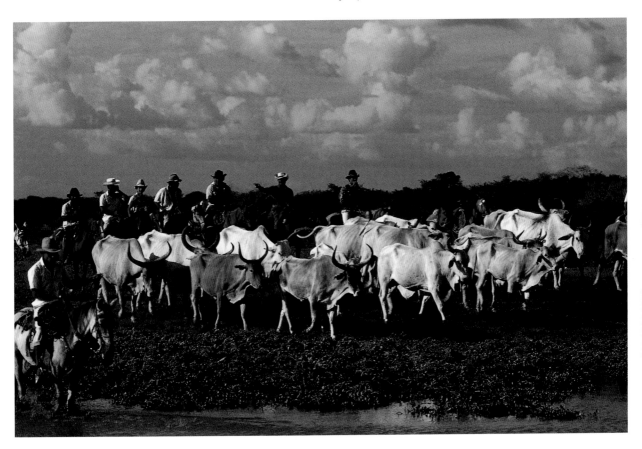

Pictogram, La Macarena National Park

These relics of ancient indigenous peoples include anthropomorphic, zoomorphic and anthropozoomorphic figures. The Angostura I archaeological site in the park has geometric ones and pictograms are also found at the Angostura II site. Little is known about the cultures who did these rock paintings.

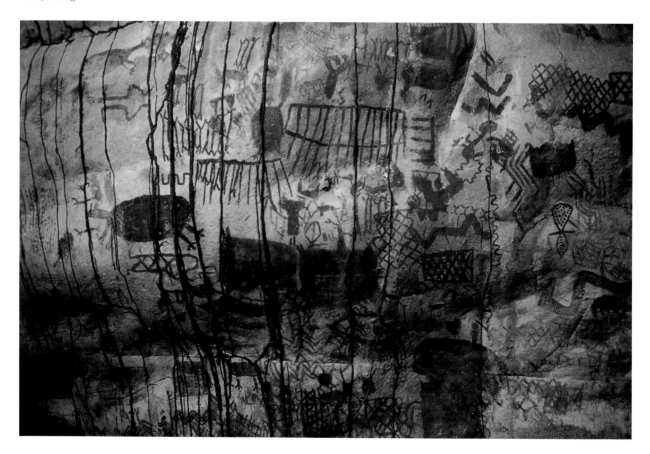

Yagua indigenous people, Department of Amazonas

The few surviving Yaguas live on both the Colombian and the Peruvian banks of the Amazon. In the past extended families lived in communal long-houses, known as *malokas*, but their settlements are now made up of individual, stilted houses spread around a school or a soccer field.

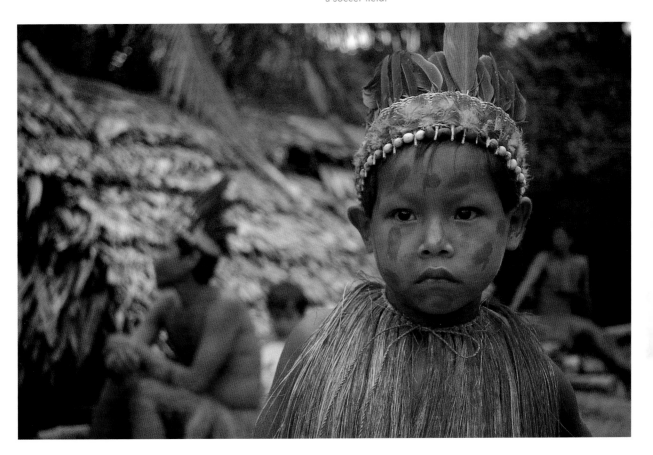

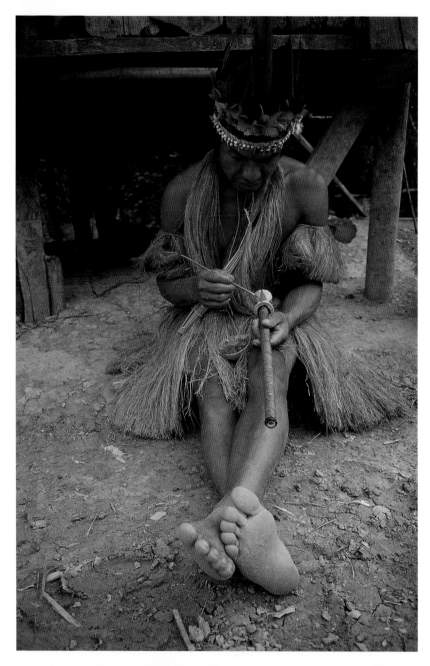

Yagua indigenous man, Amazonas

The Yaguas live off hunting (which still has an important ritualistic significance), fishing, food-gathering and the growing of sweet manioc, maize, taro, sugar cane, fruit and tobacco on small plots. In recent years, fishing has turned into their main economic activity.

Ticuna indigenous dancers, Amazonas

The Ticuna ethnic group is the majority one in parts of the Colombian Amazon, although they also live in different parts of the jungles of Brazil and Peru. They are excellent hunters and woodcarvers. They still conserve a close relationship with their natural surroundings.

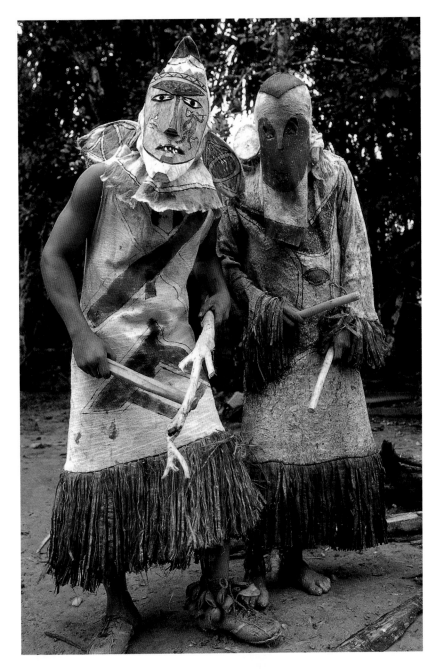

Museo Nacional – National Museum, Bogotá

The photo shows the rotunda on the third floor of the museum, which
was built as a panopticon prison. It exhibits cover the arts, crafts, in-
dustries and daily life of Colombia. The pictures framing the entrance
to the gallery are by Alipio Jaramillo and from left to right, paintings by
Luis Alberto Acuña, Alejandro Obregón and Carlos Correa.

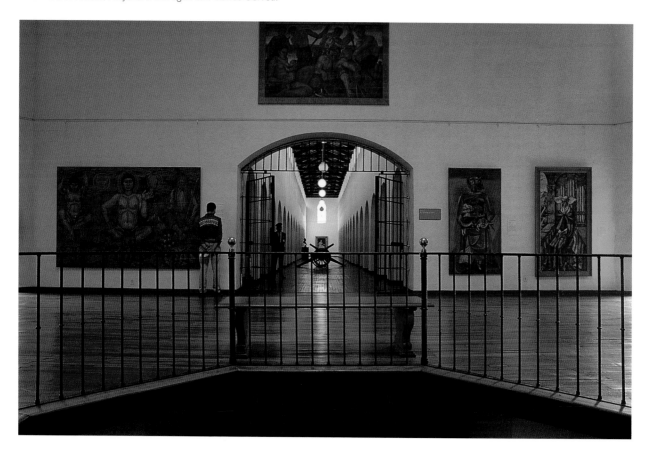

Church of the Immaculate Conception, Manizales

The first stone of this church, located in the Caldas park, was laid in 1903 and it was inaugurated on March 24, 1921. Built in the neo-Gothic style, it has a floor plan in the shape of a Latin Cross, three naves and an apse. It features a profusion of richly carved cedar-wood ornaments, done by local craftsmen.

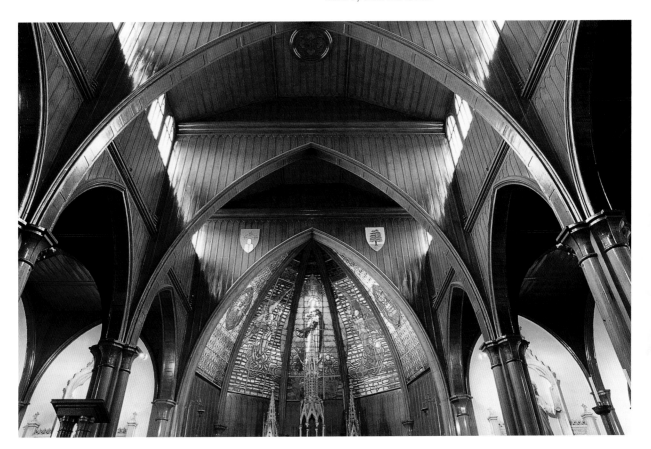

A symbol of power and mystery, the enigmatic color black is defined by the absence of light and color. Although it has always been associated with fear and the unknown, it nevertheless represents authority, strength and intransigence as well. It is no doubt the color of elegance, seduction and silence; of Edgar Allen Poe's *The Raven*; the color of evil, secrecy, sadness, misfortune, anger and also irritability. An indispensable part of any picture, it is also the color of death and mourning in Western culture. The Spanish word for it is *negro*, which comes from the Latin *niger*. Black is found in the torrential waters of the seas before a storm, the keys of a piano and the statues of the nation's founding fathers. It also features in the cupolas of a number of churches and cathedrals, the coloring of diverse animal species (like the deep black eyes of bears) and the legendary avenida Jiménez in Bogotá.

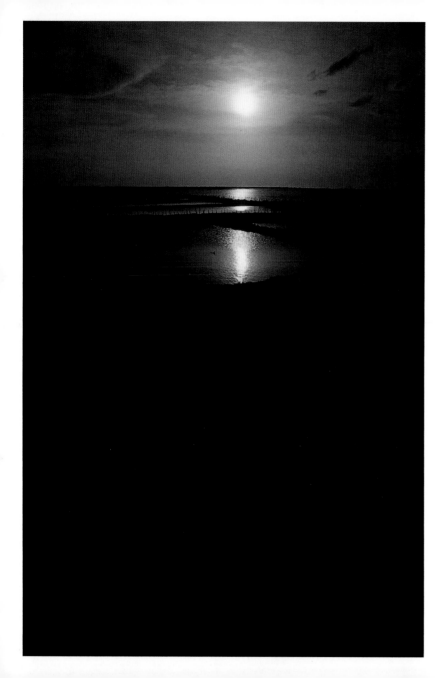

Manaure, La Guajira

The poet Eduardo Zalamea called La Guajira "Land of burning thirst, of wasting kisses, of exhausting sun, of vague mystery." Another writer, Arturo Camacho Ramírez spoke of the "wind which whips up in the saltworks like an impalpable tongue, stealing its savor, scoring us with a rake of hot thorns."

Archive of Bogotá

Work of the architect Juan Pablo Ortiz, the Archive, was inaugurated on August 6, 2003. It conserves a wide range of documentary, cartographic and audiovisual material which records the history of Bogotá, including a special collection about the city's public transport companies.

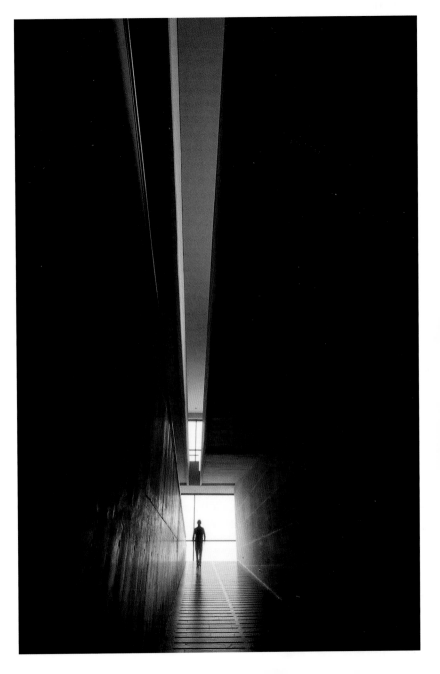

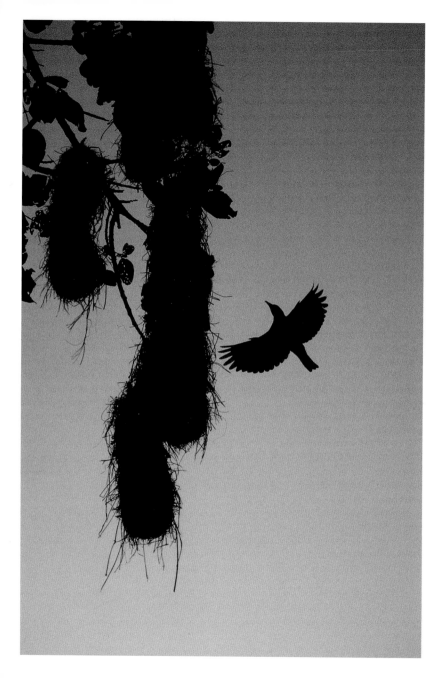

Oropendola

A bird nearly endemic in Colombia territory, it usually lives in flocks and builds nests, which hang from tall trees, in the form of a long pouch, hence the name *mochilero*, which comes from *mochila* a traditional shoulder bag.

Gulf of Utría, Chocó

Situated along the rugged Pacific coast of Colombia, it is rich in biodiversity and a refuge for endemic species of plants and animals. It is hemmed in by the Baudó range and is watered by fast-flowing rivers.

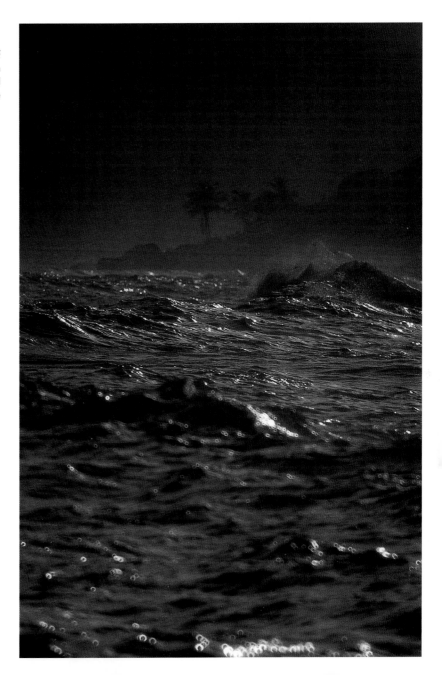

This is one of the most important archaeological sites in South America, the origins of which are still unknown. This statue has an unusual face, which may represent a mask; the position of the hands is also strange. It stands on Mesita C of the necropolis, which does not have small pavilions like the other plateaus, but does possess highly-finished works.

Mud volcano, Arboletes, Antioquia

Situated in the part of Urabá that lies in the Department of Antioquia, some 200 meters from the beach, it is a place where hut mud issues from the ground, which is a mixture of subsoil rocks, clay, steam and magmatic gases. A soak in the warm bubbles of mud, followed by a dip in the sea, is an unforgettable experience.

Crater of the Puracé Volcano, Cauca

This active volcano, which is the tutelary mountain of Popayán, with eruptions which have gone down in history, is the northernmost peak of the Coconucos range, which has many craters with sonorous indigenous names like Chuliquinga, Shaka, Machancara and Amancay.

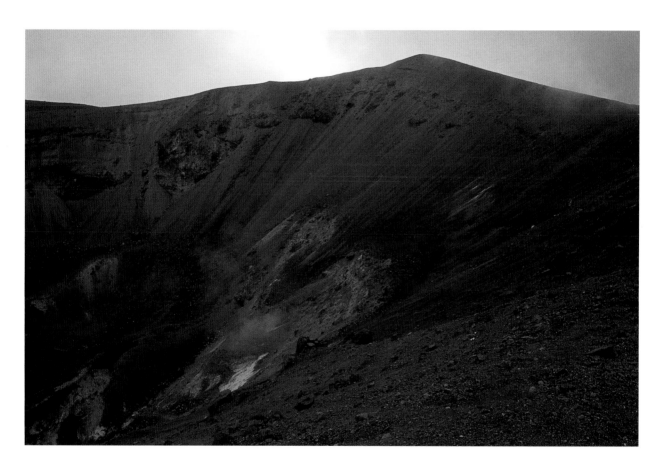

River Sinú, Sucre

345 km long, it is the second-largest river in the Caribbean region of Colombia, after the Magdalena. Its source is the Paramillo node and it flows into the bay of Cispatá. Its main port is the city of Montería. The basin of the Sinú contains the Urrá hydroelectricity reservoir and has some of the country's most fertile lands.

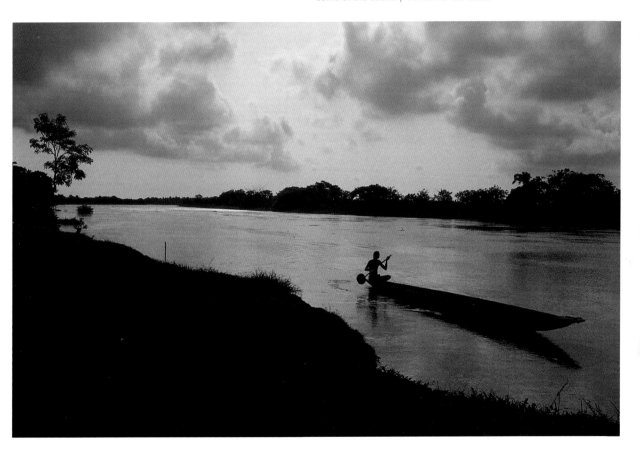

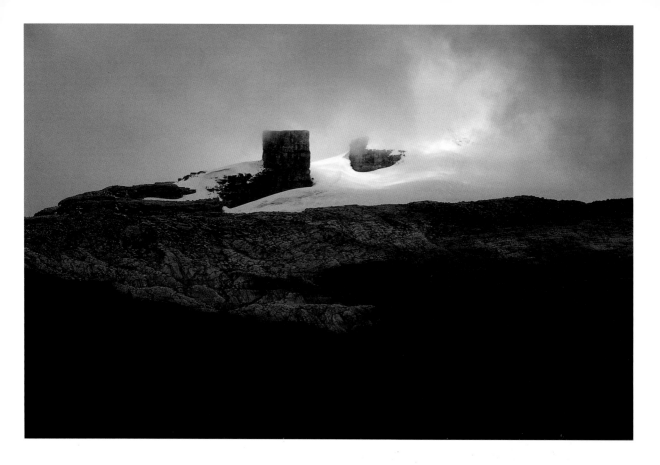

Sierra Nevada del Cocuy

This is the country's biggest glacial mass and the source of great rivers, like the Chicamocha, Casanare and Arauca. The peak on the right, covered by clouds, is the Pan de Azúcar, which, at 5 100 meters above sea level, is the highest in the Eastern Cordillera. Beside it one can see the rock formation known as the Devil's Pulpit, at 4 900 meters above sea level.

La Cocora Valley

This valley is the home of the beautiful wax-palm, *Ceroxylon quindiuense*. Of the eleven species of *Ceroxylon* which grow in the Andes, seven are found in Colombia. Its red fruits are food for the yellow-eared owl *Ognorhynchus icterotis*, which, like the wax-palm, is on the edge of extinction.

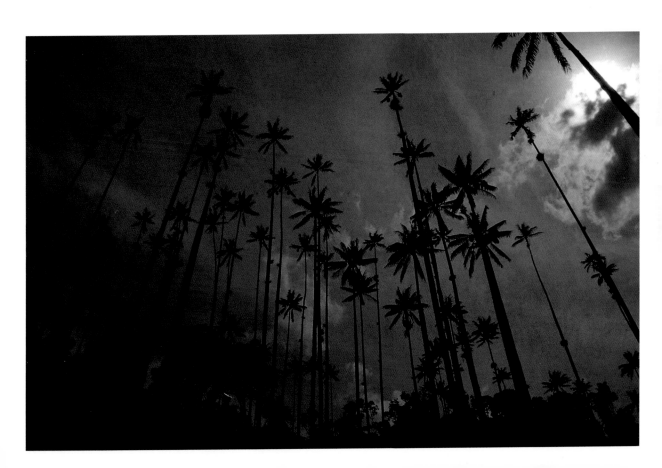

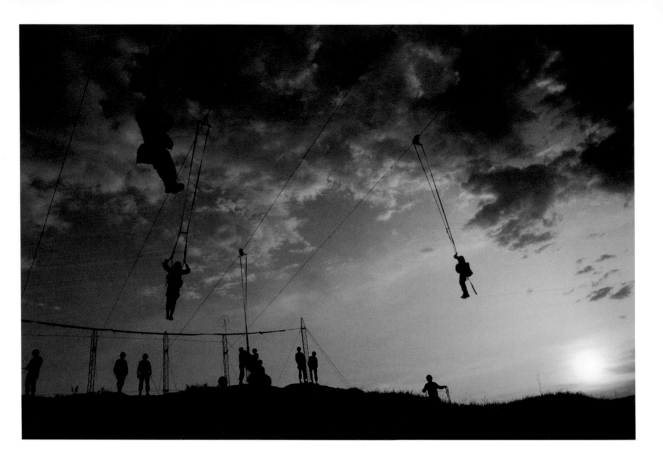

Tolemaida Fort, Melgar, Tolima

In 1954, General Rojas Pinilla, the President of Colombia, ordered this
fort to be built on the banks of the River Sumapaz. It is the headquar-
ters of several army batallions, the school of lancers, the parachute
school, the tenth brigade and Gustavo Rojas Pinilla military airport.

Puracé National Natural Park

This park lies in the Colombian Massif, also known as the Almaguer node. It is a source of many rivers, including the Patía, Magdalena, Cauca and Caquetá. It contains large stretches of paramo or high Andean moorland which harbor endemic species like the *frailejón* (of the Espeletia family), *chusque-bamboo* and scrubs.

Plaza de Bolívar, Bogotá

The main square of Bogotá, it is the political and historic heart of the city. The buildings surrounding it include the Palacio Liévano, the Primatial Cathedral, the Sagrario Chapel, the Archbishop's Palace and the National Capitol. In its center stands a statue of the Liberator, Simón Bolívar, by Pietro Tenerani, which was placed there in 1846.

International Kite-Flying Festival, Bogotá

This is part of the Summer Festival, the city's most important leisure event. In the month of August, kite enthusiasts from different countries fly the kites they have built in different parks, accompanied by those of the city's children.

Corralejas, Sincé, Department of Sucre

This is a traditional fiesta which includes cockfights, beauty queen contests, processions of horsemen and dances. Its origin is religious, the 20th of January being the day of the Sweet Name of Jesus. Dating back to the 19th century, it is one of the most colorful and popular celebrations in Sucre.

La Planada National Natural Park, Nariño

The bespectacled bear seen here, *Tremarctos ornatus*, lives in the cloud forest. It is very timid, a great climber, largely vegetarian and besides being the second-largest mammal, after the tapir, it is the only bear in South America. Large-scale deforestation and thoughtless hunting threaten it with extinction.

San Martín Plaza, International Center, Bogotá

This monument to a heroe of the Independence, José de San Martín, is a copy of the sculpture by the French artist Louis Damaus, which stands in the plaza San Martín of Buenos Aires. It was erected in 1941 and is found on calle 32 where the carrera septima joins the carrera trece, in front of the Bavaria International Center and diagonal to the National Museum.

Monument to the Race, La Alpujarra, Medellín, Antioquia

The work of the famous Colombian sculptor Rodrigo Arenas Betancourt, this bronze and concrete statue is 38 meters-high and was built between 1979 and 1986. It is a tribute to the *Paisas*, the inhabitants of Antioquia, who are symbolically shown rising from the earth in a spiral movement to reach the sky, where they seek communion with God.

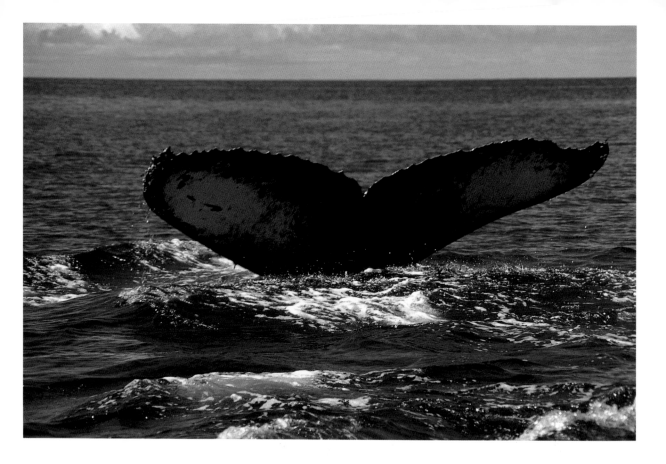

Humpbacked whale, Pacific ocean

The sea of Gorgona is a veritable living laboratory. It is frequented by dolphins, porpoises, sperm whales and, in the summer months, by the *yubarta* or hunchbacked whale, which arrives at the island to find a mate and breed. Colombia takes great care to preserve this natural wonder.

Gorgona National Natural Park, Cauca

An island 36 km off the Pacific coast, it was visited by indigenous chiefs, adventurers, conquistadores, soldiers and scientists and was once used as a penal colony. It has an equally rich biodiversity. It is watered by more than 25 streams and has forests, cliffs, beaches and boulders that rise out of the sea, plus a rich submarine life.

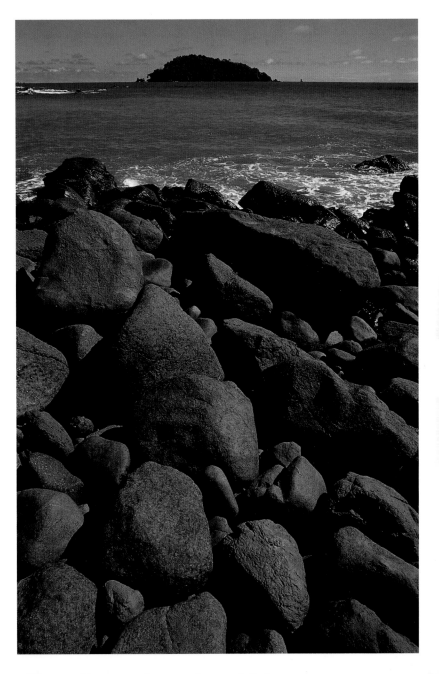

Parque Jaime Duque, Sopó, Cundinamarca

The enormous head of a Tyrannosaurus Rex stands at the entrance to the Dinosaur Garden, one of the attractions of this theme park. Pictures inside a gigantic Brontosaurus (34 meters long and 14 meters high) explain the evolution of these creatures and their disappearance millions of years ago.

Cuadrillas de San Martín, Meta

In 1735 the Spanish missionary Gabino de Balboa created this version of the games of the Achagua natives. The participants are divided into four *cuadrillas* or squadrons — Moors or Arabs, gallants or Spaniards, Guahibos or Indians and Cacheros or Africans — which engage in breathtaking equestrian competitions.

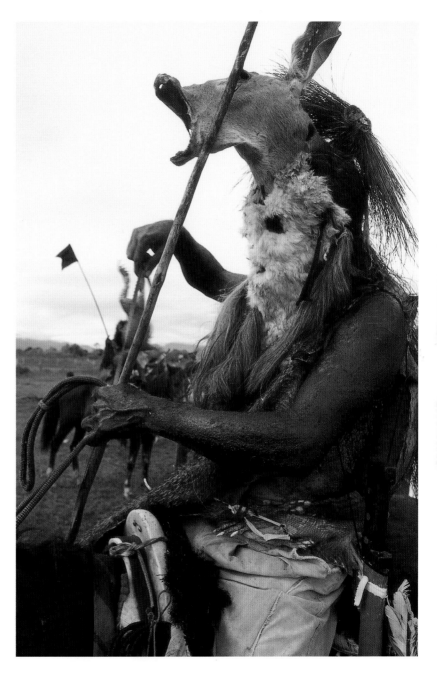

THE END